PAINTING
TREES & LANDSCAPES
IN WATERCOLOR

TED KAUTZKY, N.A.

VNR Van Nostrand Reinhold Company
New York Cincinnati Toronto London Melbourne

First published in paperback in 1980
Copyright © 1952 by Litton Educational Publishing,
Inc.
Library of Congress Catalog Card Number 52-10618
ISBN 0-442-21918-0

Van Nostrand Reinhold Company
A division of Litton Educational Publishing, Inc.
135 West 50th Street, New York, NY 10020

Van Nostrand Reinhold Ltd.
1410 Birchmount Road, Scarborough, Ontario
M1P 2E7

Van Nostrand Reinhold Australia Pty. Ltd.
17 Queen Street, Mitcham, Victoria 3132

Van Nostraand Reinhold Company Ltd.
Molly Millars Lane, Wokingham, Berkshire, England
RG11 2PY

Cloth edition published 1952 by Reinhold Publishing
Corporation
Thirteen cloth impressions

16 15 14 13 12 10 9 8 7 6 5 4 3 2 1

TABLE OF CONTENTS

COLOR PLATES

INTRODUCTION

The present book has been written to afford the reader an opportunity to learn about a number of elements that appear time and again in almost every landscape. In each of these, I have presented only enough fact to serve the artist's need—placing the emphasis on a workmanlike approach to the way of achieving a particular effect.

Since trees are a vital part of many landscapes, a large part of the book has been devoted to a general study of a selection of them. But I want to stress at the outset, that my object in writing about trees has not been directed to the botanist—even the amateur botanist—but rather, to the student of watercolor painting. Nor has it been my intention to suggest that my way of painting trees and landscapes is the only way. There are many.

Certain features of a tree are important to every painter regardless of the technique or manner of expression he may employ in painting them. These are: the general form; scale; the kind of foliage; structure of its trunk, limbs and branches; the color and textures; and its general appearance, with or without foliage. For each of the varieties, I have prepared numerous illustrations to demonstrate these facts.

Preceding the actual writing of the book but in active preparation for it, I spent a number of months sketching and painting in various sections of the United States. All of the sixteen watercolors reproduced in color were painted especially for this volume. In order to present each variety of tree in a typical setting and atmosphere, and at the same time to paint pleasant landscapes, I have given equal attention to all of the elements in each one—so that the reader might see a developed composition in color.

For each of these pictures, I have analyzed the composition briefly and given pertinent facts concerning my choice of paper, palette, and painting order. Also, as a teaching aid, there is included a half-stage illustration (painted *after* the completion of the finished watercolor) to demonstrate graphically the initial stages—revealing in addition, the skeleton pencil draft.

The reader will also find chapters on composition, value arrangements, fog and rain, puddles, various types of roads, and a chapter on forests.

Throughout the book, I have demonstrated by example technical procedures for painting all of these subjects—including typical brush strokes for modeling foliage, trunks, limbs and branches. Finally at the end, there will be found a series of pencil outline compositions which will aid the student in trying out various color schemes and value arrangements. They will prove of value only if the reader will study the book in sequence from the beginning. These are not intended to substitute for actual study in the field—there is no substitute for firsthand knowledge acquired by diligent study of nature—but rather, as a series of studio exercises to assist the student in working out the various hints which accompany each drawing. With the popularity of watercolor growing steadily, I hope that the study of this book will increase the knowledge of the student and provide a benefit in his watercolor practice.

MATERIALS

For the best results, watercolor painting requires the use of good materials. This is particularly true of the three basic tools: paper, pigment and brushes.

My own preference in paper is always a handmade sheet of rough or semi-rough, all rag stock, in a 300 pound weight. Such a paper, manufactured abroad and known as Whatman, D'-Arches, Crisbrook and Royal Water Color Society, comes in full sheets measuring 22 by 30 inches.

I use a half sheet for most of my outdoor paintings and a full sheet when working in the studio from my pencil drawings and outdoor color studies.

Paper of a dubious quality is not only a handicap in the actual appreciation of the color washes, but its chemical impurities will cause deterioration in an otherwise fine performance in color. The economy of these papers I have recommended in a 300 pound weight lies in the fact that both sides are equally well sized and may be used. The D'Arches paper, unlike the others mentioned, is not pure white, being manufactured of bleached rag, but has a real advantage in painting watercolors of fog, rain and mist. For subjects of strong light contrasts, I prefer the whiteness of Whatman or Crisbrook. Of the more than one hundred watercolor pigments available to artists, most successful painters use a palette consisting of about ten to twenty colors. As in the case of paper, the chemical purity and permanence of the pigment are of vital importance. I prefer the transparent watercolor manufactured by Winsor & Newton or Grumbacher. My own palette consists of two reds: *Alizarin Crimson* and *Vermilion Red*—the first a cool red, the second, a warm one; four yellows: *Cadmium Orange, Cadmium Yellow, Aureolin Yellow* and *Cadmium Lemon;* three blues: *French Ultramarine* (which I use most frequently for its rich intensity, its ability to mix well with other colors and its characteristic in "settling washes"), *Cobalt,* especially useful in the painting of summer skies, *Winsor* and *Cerulean Blue,* for cool passages of sky and mountains; a green: *Hooker's Green Number 2,* which I lighten or darken with a mixture of a blue or a yellow.

The earth colors, made from the oxides found in the natural soil, provide the watercolorist with warm, brownish tones so useful in painting landscape. I use the two *Siennas, raw and burnt,* and both *raw and burnt Umber.*

For the neutralizing of various color washes and mixtures, I employ two grays: *Davy's Gray,* which has a warm tone, and *Payne's Gray,* which is cool. Finally, I make occasional use of *Sepia* —a warm, brownish gray, which I use for monochrome studies.

Again, I advise buying a few good brushes of the best quality. For most of my work I use the flat, square-end sign painters' ox-hair brushes—the half-inch for general use, and the one-inch for the larger washes. You will also need at least two round brushes—a small one, number 2 or 3, for details, and a large one, a number 12, for medium sized washes. If possible, get these in red sable.

In my previous book, *Ways with Watercolor,* I have gone into much greater detail concerning my materials.

COMPOSITION

Perhaps the most important consideration in the painting of successful pictures in any medium is the design or composition. Nature provides the artist with inspiration, motifs, color and arresting forms, but the business of arranging any and all elements into a pleasing design is the vital problem of organization.

When going out to paint a landscape, the first thing to do is to arrange all of your materials and equipment in good order.

Next, do not make the mistake of traveling in circles hoping to find the perfect subject ready-made for you. Make it a practice to stop at the *first* subject that attracts you and get to work. But this does not mean you should start painting immediately. Walk around the subject and try to select a point of view that lends itself to the best position with full consideration for the light direction and the most attractive deposition of the major masses.

Having selected your position, take time to make one or more preliminary drawings in small scale, placing the accent on the simplest pattern.

Painting a picture is like building a house. First comes the plan, next the construction of the framework, and *finally*, the refining details of ornamentation, color and textures.

As an aid in making my initial remarks concerning composition clearer, I have prepared the group of examples following. In each of these three sets, I have used the same general subject matter. In the examples on the left, the design indicates a less than satisfactory composition; those on the right of each present a re-arrangement with additional elements, providing better pictures.

Starting at the top, example number 1 shows a monotonous arrangement. The barn and silo are centered, left to right; the flanking trees and mountain background are too evenly spaced.

In number 2, variety of pattern and informal balance have been achieved by the placement of the barn off center to the left; the curvature of the road has been accentuated in the foreground; and a willow has been added in the middle distance. The large tree to the right, reflected in the mud puddle, has also added interest.

Number 3 has considerable line movement but fails to contain itself within the picture plane, as the perspective lines of sky, trees, and distant mountain all lead out of the picture, from the upper left to the lower right. As a counterbalance for this fault, in number 4, I have introduced a clump of dark tree forms on the right bank, and changed the slant of the mountain outline. Notice too, that the trees to the right being barren of foliage, provide a marked contrast to the fullness of the other tree masses.

In example number 5, we find the picture optically overweighted on the left side. Only by cropping it about one-third on the right, could proper balance be effected—which would make an upright shape instead of a horizontal one. By adding the two trees on the right side, and increasing the dark mass of trees in the middle distance farther to the right, number 6 becomes a well-balanced and more interesting composition. The changes that have been discussed

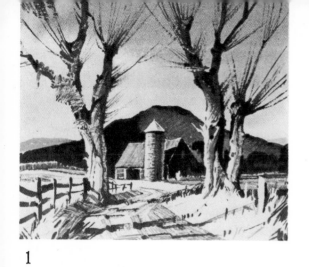

1

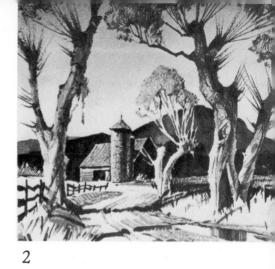

2

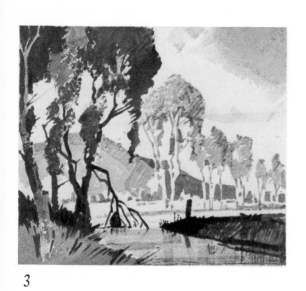

3

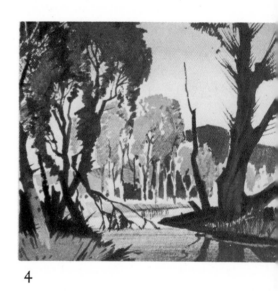

4

5

6

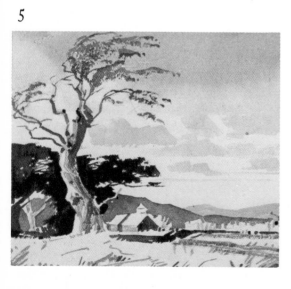

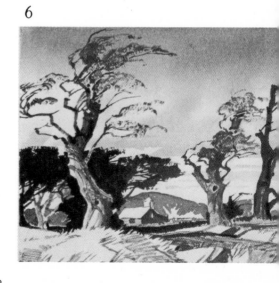

and graphically shown here are in effect the kind of preliminary sketches I have recommended in the beginning of this chapter. It is not necessary to make them as complete as I have to serve the important purpose. Pencil may be substituted for the Sepia wash. The significant thing about it is that by making two or more studies prior to plotting the composition on your watercolor paper, much of the trial and error will be eliminated.

A very dramatic effect may be produced by a low eye level, intercepted by tall verticals. This is displayed in example 7, but it has the same monotony as example 1, on page 8. The even spacing of the trees with each one rising to the top produces a static effect that acts as a barrier to the eye. Now examine the following picture (number 8). I have eliminated one tree, and in re-spacing the others, opened up a passage for the road. The simple device of placing the white house foiled against the dark of the mountain carries the eye into the background. Also note that the second tree from the left side does not carry to the top and thereby helps to stop the vertical movement, returning the interest to the horizontal plane.

Now we come to four separate pictures that demonstrate particular features which need special explanation.

In painting mountains, and in fact all angular forms, there is a natural tendency to create monotony through the paralleling lines. I have tried to avoid this situation in number 9 of the mountain picture, by supporting the pyramidal snow-capped peak by a series of contrasting obliques. The eye, entering the composition on the flat foreground plane, is carried in a series of zigzag movements to the topmost peak. The larger masses are broken up with textural indications and varied in pattern by contrasting values. Distances are further enhanced by the receding scale of the trees, from those in the foreground to those suggested on the slopes. The giant Sequoias in picture number 10 would not impress us with their great scale were it not for the presence of the pines introduced alongside of them in the middle distance. This device of providing a unit of familiar measure—like a figure or animal—immediately creates the illusion of contrasting scale.

If you select a subject to paint that does not have perspective lines which lead *into* the picture (such as we find in examples 7 and 12), the illusion of depth may be obtained by varying the spacing of the parallel forms—shadows on the ground, a horizon line, or in the sky area, the cloud forms.

I have put this principle to work in picture number 11. The horizontal spacing diminishes from foreground to horizon on the ground plane, and also in the cloud forms, from the top to the horizon. The depth is further enhanced by the value arrangement which will be taken up in the next chapter.

Picture number 12 presents one of the most powerful devices in composition, wherein all of the perspective lines— of the roadway, trees and telephone lines—lead the eye to a point of convergence at the horizon. In painting this kind of picture, it is important to avoid placing the point where all the perspective lines converge in the dead center. I have avoided this by (1) using a low eye level and (2) by forcing the end of the road off center, to the right.

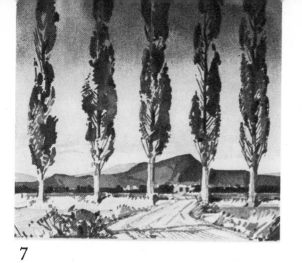

7

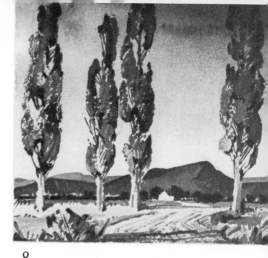

8

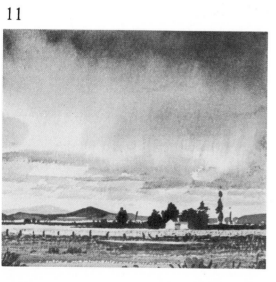

9

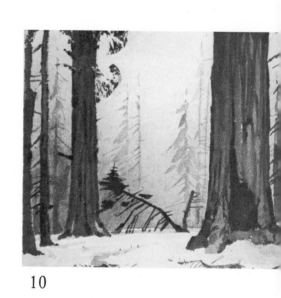

10

11

12

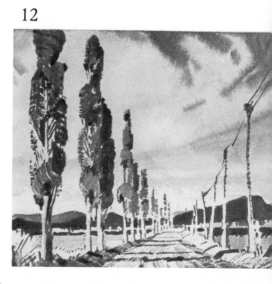

VALUE ARRANGEMENT

Values in watercolor painting often present the artist with more problems than color. In his desire to record local color and atmosphere, the painter sometimes fails to produce the *correct* value. His darks are often not dark enough and his light values, too dark. This is the reason that it is altogether possible for the experienced artist working with a limited palette to paint a very successful picture, *if* his values are convincing. We have only to look back in the history of art and to reproductions of some of the early watercolor masters who worked with a few simple colors, but who had a thorough command of values, to realize the truth of this statement.

The six illustrations following are all tone variants of the same pictorial composition. From any one of these value studies (and here again I wish to emphasize the importance of the preliminary sketch) one could paint a picture in full color. While these examples are arbitrary value arrangements, each one is possible under proper conditions. Now let's examine each picture and analyze the value scheme, confining our major attention to the three principal tones. In number 1, the foreground of roadway and tree is a medium dark value; the middleground of house and smaller trees is the darkest value; and the mountain in the background is a simple silhouette of light value. Details within each of the principal values—such as cast shadows, textures in roadway, trees and grass—should be regarded as belonging to the overall pattern of each of the three major values. The next example, number 2, presents a contrasting value scheme. Here, the foreground is cast in the lightest value, with the middleground in the medium dark value, and the background mountain in the darkest value.

Next, in number 3, the foreground is the darkest, the middleground is the medium dark and the mountain background is the lightest value. Picture 4 has the same foreground value as number 2, but the values of middleground and background are reversed: the house and smaller trees in the middle distance are the darkest value, with the mountain background the medium dark.

In picture 5, the value arrangement creates a dramatic accent in the middleground by foiling its light value against the background, which is dark. The final illustration (No. 6) also gives dominance to the house and trees in the middleground by contrast with the darkest value foreground, and a middle dark background.

In making value studies such as these, the object is to keep the individual detail subordinate to the major tone masses. The student could not be directed to finer examples than the preliminary drawings of Rembrandt and Goya. These masters evolved some of their greatest works from miniature studies in which the great emphasis was placed on value patterns and value contrasts. This virtue may be seen carried out in their prints (in monochrome) as well as in their paintings in full color.

I would like to suggest that readers who are anxious to improve their handling of values would benefit by making six similar value studies of one of their own paintings. You will find it an invaluable experience and not a mere exercise.

1

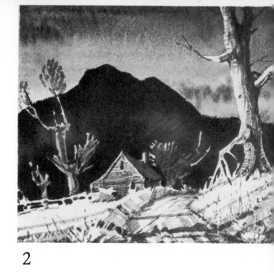

2

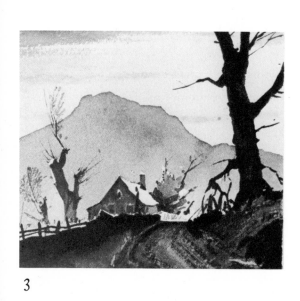

3

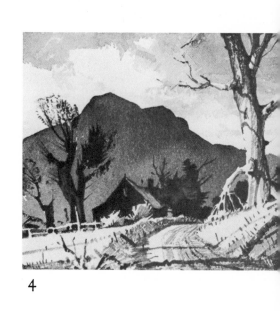

4

5

6

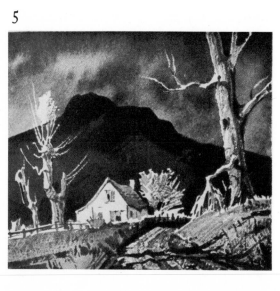

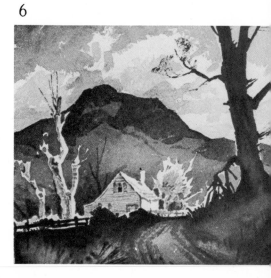

FOG AND RAIN

While the painting of subjects in strong contrasts of sunlight and shadow produce colorful pictures, artists ought not to neglect the opportunity to tackle the atmospheric qualities created by fog and rain.

Fog obscures details, especially in the middle distance and background, creating silhouettes. Local color loses its original identity and takes on the color tone of the fog, as the planes recede into the background. Fog is usually a purple gray, a gray green, or a neutral gray. The foreground color however is less affected, although here too the grayness of the general atmosphere reduces tone values into subtle relationships. Usually the foreground is the darkest value in a picture under conditions of fog or rain. My palette for painting fog and rain is usually composed of French Ultramarine Blue, Burnt Umber, Hooker's Green No. 2 and Davy's Gray.

There are two ways to create this misty effect. In the first one, I wet the paper with sponge or brush in that section of the composition which is affected most by the fog—usually the background. Into this dampened area I paint the forms with my brush loaded with pigment, adding only a little water. Too much water would cause the already saturated paper to spread the color beyond control.

The second way calls for painting the whole picture on dry paper. After the washes have dried thoroughly, I superimpose clean water with a brush to soften and to blur slightly those sections which require the greatest fog effects, working quickly to avoid brush marks. The painting at the top of the following page was painted in the following order. The general composition was lightly indicated in pencil outline and the first color wash was concentrated on the dark tree form, in the right foreground. This was kept as dark as I could make it, without losing transparency. Next, the trees in the left foreground were painted similarly. The road was my next consideration, and here again I related the dark foreground to the value of the larger trees, graduating the wash from the immediate foreground to the high-lighted area in the middle distance. The architectural forms were indicated next, and like the roadway, painted from dark to light, as the planes receded into the background.

The misty quality of the fog in the central background was achieved by painting the sky and farthest tree on a wet surface. When this area had dried, I superimposed the next elm in a slightly darker value. Finally, the details of foliage, sky, architecture and textures were added, combining dry - brush strokes with normal washes.

Throughout this picture, I worked from foreground to background, graduating values and sharpness of detail to create the atmospheric effect.

The New England street scene below was painted in the same general order, except that in this picture, I reserved white paper areas of the rooftops to indicate their wetness. To further the illusion of rain, I used reflections of the trees and sky in the immediate foreground. The sky was painted last, concentrating the lightest value (white paper) as the foil for the silhouette of the church steeple.

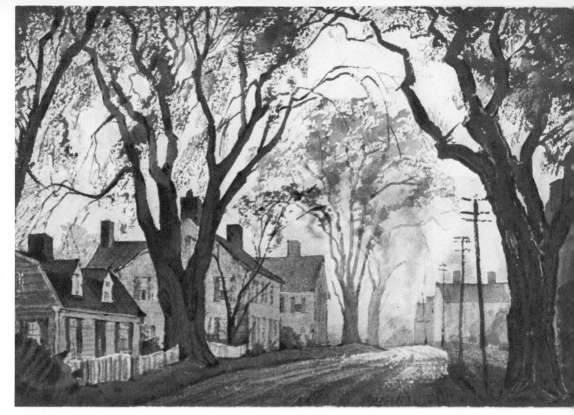

FOG

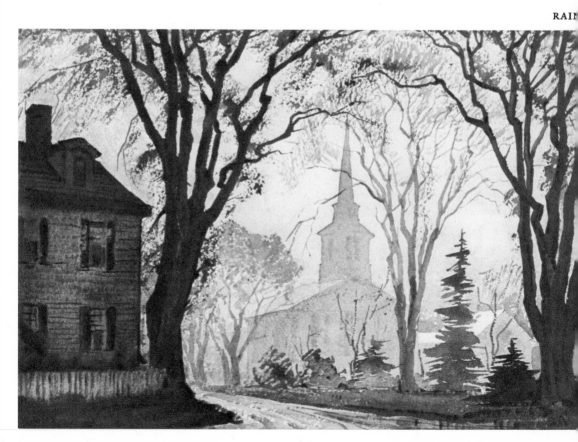

Puddles in a roadway, which so often form in the depressions of dirt roads after a rain, or in the Spring with the melting of snow, can be so interesting that they often become the dominant note in a picture. This is illustrated in the top painting on the following page. Here we have a simple landscape that, without the light puddle in the foreground, would certainly have lacked a center of interest. With it, the picture becomes alive, the long curves of the meandering road are made more rhythmical by the opposing shape of the pool outlines. The eye passes easily throughout the entire composition returning to rest on the brilliance of the puddle, which, in reflecting the sky overhead, is a light passage.

In painting this watercolor, I first worked in the sky on a wet surface, leaving the passage directly over the mountain tops to the left of center, the white of the paper. Next came the mountain silhouettes in the background, with the farthermost one lightest in value. The middleground, with its dark pattern of trees, farmhouse and field, was indicated, to be followed in order by the embankment of the road and the clump of trees on the right.

By this time, I had established all of my related values, from the top of the painting to the inside edge of the roadway. Below this point was still white paper, except for the pencil lines of my initial drawing. The road now was brushed in with a middle value wash, leaving the puddle area the white of the paper. I was careful to keep the water edges of the puddle sharply and crisply formed. The value of the road was darkened slightly along the outline. The dark of the right foreground was next related to the road, and finally, the few reflections of the trees to the right were indicated. Note that the edge of the puddle next to the road embankment is separated from its reflections by a light streak. This device helps to maintain the correctness of the water plane.

The next picture following has a very different character from the one above it. The perspective of the dirt road carries the eye directly from the immediate foreground up the rising grade, until the road makes a final turn and is lost sight of, only to be continued in movement along the blurred edge of the hill in the left background. Notice the perspective lines in the roadway in the immediate foreground.

Unlike the illustration above it, this picture, with its compelling roadway and the large mass of house and barn, finds the puddle in the right foreground, an interesting but secondary motif. Here the dark reflections are edged by white surface streaks, especially along its contours. The horizontal streak in the middle of the puddle, by being spaced beyond the center, helps to create the illusion of space depth.

The order of painting this picture was the same as the top one, and its atmosphere and textures effected in the same manner. By leaving accents of white paper on the rooftops and in the foreground of the road, the strong linear movement, previously discussed, is brought under control.

To sum up, remember: a light valued puddle has a dark edge; a dark valued puddle has a light edge.

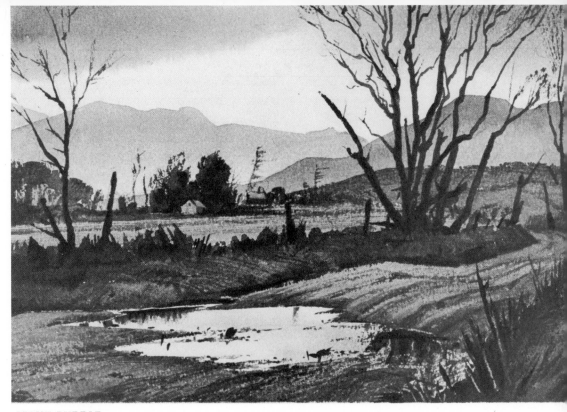

LIGHT PUDDLE

DARK PUDDL

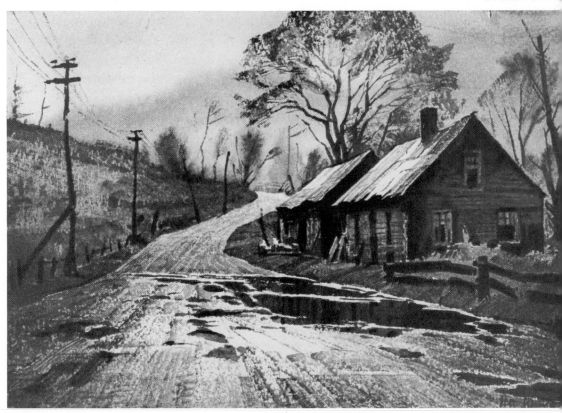

ON PAINTING ROADS

From the Renaissance down to our own time, the landscape painter has found the road an arresting feature in much of his work. Therefore, it is important for the artist to study roads in order to paint them with confidence and authority.

Roads are not all alike, they vary in color and texture according to their structure and surface. When dry and under sunlight condition they present a very different aspect than when they are wet with rain. In the balance of this chapter we will discuss four road surfaces: concrete, macadam, dirt, and hard gravel—illustrations for which will be found on pages 18 and 20.

The main characteristics of the concrete road are: (1) the general lightness of its color; (2) the longitudinal dark stripes caused by automobile oil; (3) the mechanically smooth surface; (4) the slight crown or curvature in section; (5) the sharp edges at the shoulders; and (6) the shoulders, which are usually gravel. The concrete road in the watercolor at the top (page 18) was painted with dry-brush strokes, following the perspective lines, and working from the immediate foreground to the middle distance, where their speed and identity are lost. To avoid monotony, a few horizontal lines were introduced, graduating their spacing to achieve depth. Where the sun strikes this road at the right side the value is lightest; it becomes slightly darker on the left side. The cast shadows seen here are more transparent and warmer in the foreground than those in the middle distance and background, where they should be painted in a cooler tone. One further note about a visual detail of concrete roads: avoid accentuating the dark expansion joints— better eliminate these entirely.

The macadam road, which is composed of crushed blue stone and tar, is dark in value and color. Since it does not readily absorb water, it often has a strong sheen when wet, causing dark reflections. Frost pockets develop under conditions of extreme cold followed by thaw. Ruts are made in the surface by heavy traffic, especially during warm weather when the macadam has a soft, rubber-like quality. Such variations in surface create more interest for the artist than for the road commissioner! In painting macadam roads—and, in fact, all roads—the drawing cannot be over-emphasized. In your pencil draft, pay particular attention to the road's perspective, the rise and fall of its stretching surface, the straight lines and curves that make up its outlines. Remember to keep a single point of view. Do not shift from one side of the road to another in your painting or drawing. If you will study the examples opposite, you will note that in the top one, my point of view was about in the middle of the gravel shoulder on the right side; and in the lower painting, I was standing in about the middle of the roadway.

I used dry-brush strokes to build up the structure and texture of the macadam road. The reflections in the puddles in the foreground were painted with washes of color. Notice the powerful value contrast in the middle distance, where the road is highlighted. This circumstance attracted my attention in the beginning, and by using a series of graduated values from bottom to top,

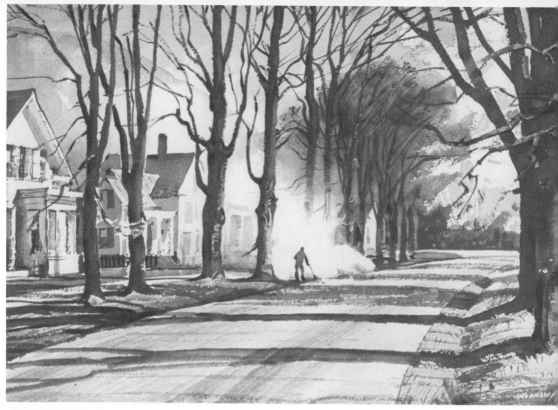

CONCRETE ROAD

MACADAM ROA

and from the left side to the right, I have made it the dominant note in this picture.

Now we come to the dirt road so common to the out-of-the-way places, where artists like to paint. Along such narrow highways, we find old fences, mellowed farmhouses, and often a variety of tree forms. Wagons and automobiles have left rhythmical ruts in the soft clay; puddles form in the depressions; a gentle rise and fall of surface produces fascinating undulations.

The following suggestions are offered to further the reader's study. First, consider the general character of the road. Indicate the particular surface of the foreground with special attention to its form. This initial pencil drawing is as important to the final success of your picture as the proportion and perspective of the farmhouse and fence.

Notice that in my picture (top of page 20), I have used a square-end brush fairly loaded with pigment to paint the general form of the road, and drybrush strokes to build up the texture of ruts and along the edges of the high lights. The cast shadows of fence and tree on the right, in falling over the road, gave me a further opportunity to accent the modeling of the ruts. Finally, attention should be directed to the many evidences here of correct perspective—especially in the architectural planes, embankments and fences that flank the roadway. The fence, alongside the farmhouse, drops away in perspective, completing the illusion of deep space and downhill movement.

The hard gravel road, made of crushed stone and pebbles, has little or no reflective quality in itself, as moisture is absorbed in its loose texture. However, it frequently develops ruts and depressions which fill with rain, as I have shown in the bottom picture on the opposite page.

When through long use, the gravel road becomes well-packed, the tiny stones that make up its physical composition create tiny sparkles of reflected light— especially when the road is rain-soaked. Such was the condition of the road in my picture. To gain this character, I allowed the rough surface of the paper to help me create this effect by leaving tiny spots of white. This texture is most clearly seen in the right foreground and in the curve of the road, in the middle distance.

In making the pencil drawing, I took special pains in forming the outlines of each puddle. First, I tried to achieve a good pattern, and secondly, I concerned myself with the perspective. Notice their design. Those in the foreground are broader in depth than those which appear farther back. Regardless of the circumstantial arrangement of puddles, one may see in his subject, that selection and artistic arrangement are far more important.

The same general technique in painting this gravel road was employed as in those previously described. Dark draglines of dry-brush strokes may be seen in the left foreground, indicating perspective. These and other surface textures were superimposed on a middle value wash. After all the other values had been established, including the ground plane, houses and trees, I added the dark reflections in the puddles. See how effective the vertical reflection in the puddle in the middle foreground of the picture is in creating the illusion of a water plane.

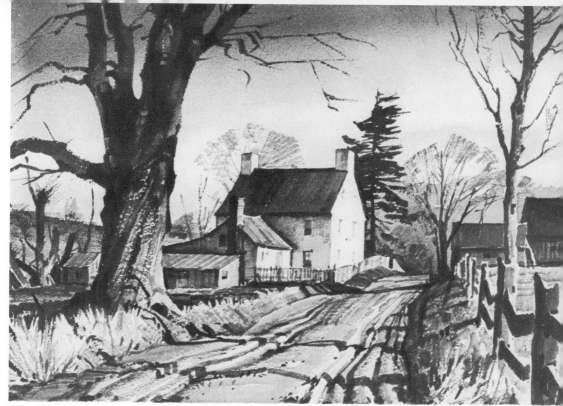

DIRT ROAD

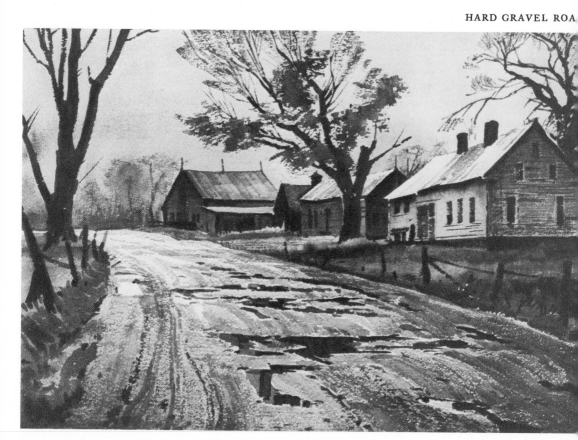

USEFUL STROKES FOR PAINTING TREES

On the following page are a number of brush strokes which will be found very useful in painting. Throughout this book you will find these used time and again in creating effects of texture and foliage and tree structure.

Illustration number 1 (at the top), indicating the vibrating character of foliage, can be made in the following way. Use the square-end brush, and after mixing the desired color, twist the charged brush in the palm of the hand until it resembles a worn broom, as shown in the drawing of the brush to the right. Use more pigment and less water. Now by applying the brush in this frayed condition to the paper you can model a mass of foliage. A small round brush was used in the lower part of number 1 to indicate bare limbs.

The next stroke shown in number 2 at the top is very useful in painting fine willow branches, hanging moss, and the foliage of palm trees. Working with the square-end brush as shown, and using more pigment than water, the stroke is accented at the bottom and lifted quickly—dragging tiny particles of color over the top of the rough paper surface. The dark branch strokes below were made with a round brush in an almost upright position.

Illustration number 3 presents two ways of creating surface textures, like the rough bark of tree trunks, etc. The square-end brush charged with pigment is held almost flat to the paper as shown and dragged lightly over the surface. The lower stroke, unlike the one above, is *pushed* away from the usual movement, creating a broken-edged line, useful in modeling rough surfaces that are illuminated by light from the side.

In illustration 4, we may see the use of the sharp edge of the square-end brush used to indicate branches connecting masses of foliage, which were painted in the technique described in plate number 1. The angle of the brush is upright and the touch is like a light tap. Practice with this brush and you will find it can be used in many places and without the necessity of changing to other sizes. The lower illustration shows the same brush producing a different texture by using the sharp edge in a side stroke, lightly touching the surface with little wetness and much pigment.

To model a smooth tree trunk like birch or beech and to indicate its three-dimensional forms, one end of the wet brush is dipped into the pigment so that the stroke when applied will look like the first one in plate number 5. This gives the effect of strong illumination from the left side. In the second example, the pigment is heavy at both ends of the brush so that when applied we find dark outlines on each side, as with the illumination from the front.

The last stroke demonstrated here (number 6) is achieved in a curious way, but the effect produced in the illustration is well worth the trouble. Take your square-end brush and charge it with a good body of pigment; now take a knife or piece of cardboard and separate the hairs into uneven divisions. Next, try out a stroke on other paper. If the effect is satisfactory, apply it to your final paper. Drag the stroke lightly as you model the form and you will see that it can create rhythmical patterns and textures of endless variety.

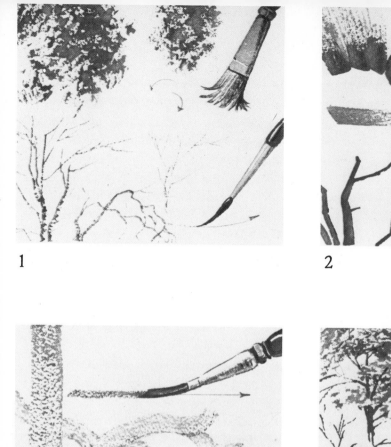

1

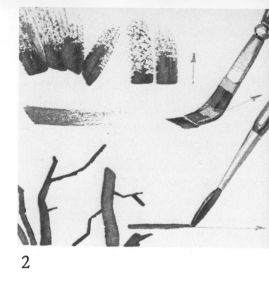

2

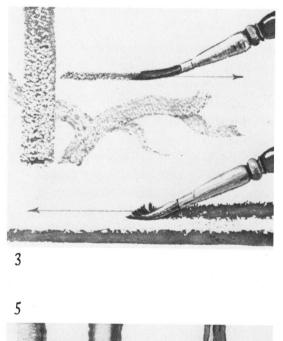

3

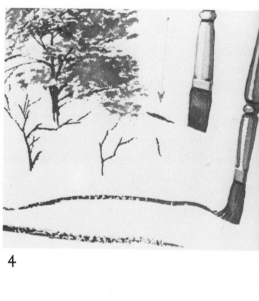

4

5

6

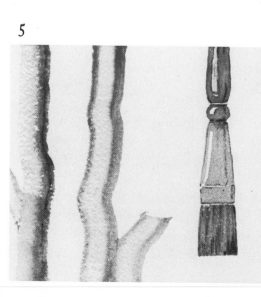

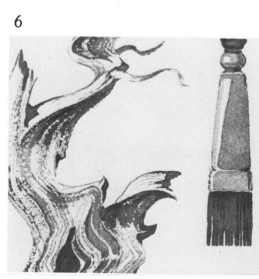

PAINTING TRUNKS AND FOLIAGE

Plate number 1 shows: the first trunk painted with a light wash with the heavier pigment on the right side; the next one with the same brush but with a faster stroke, leaving traces of texture; the third, a dry-brush stroke movement; and the fourth, a combination of two dry-brush strokes—a dark, superimposed over a light one.

Next, in plate 2, the first wash was applied to indicate the general or local color and is represented in the example to the left. The next and final step shows dry-brush stroke over-painting with a darker value indicating the rounded form and surface textures. In the third illustration, particular attention is directed to the light foreshortened limb, created by painting the dark local color *around* its pattern in the first wash application, and finally modeling its larger form with dry-brush strokes. The willow tree to the right displays characteristic contrast of heavy trunk and limbs with tiny sprouting branches. In painting this tree, the main form was created with a dark wash and while still wet, the edge of the brush was dragged along the highlighted side to produce the lighter value. This is most clearly seen on the limb growing out of the base to the left. The feathering branches may be made by either of two methods: by using the thumb to spread a tone while the dark wash is still wet, or by using a small brush, dragging out a thin series of strokes from the main body of dark value (on the trunk). The reflected light seen on the left side of the main trunk was produced by using the blade of a knife, held almost flat to the surface, and squeezing the color out. While that may be accomplished while the wash is still damp (but not too wet), a particular passage may be dampened at any time and the process executed.

Plate number 4 pictures a birch and a pine. The birch tree was painted largely with dry-brush strokes as demonstrated in illustration number 3, on page 22. The foliage masses were worked *around* the white limbs. This is clearly shown in the lowest trunks. Final accents of form were made with a small round brush, to indicate branches, connecting and supporting the foliage patterns.

The pine tree in number 4 was painted with a medium-sized, square-end brush. The clusters of pine needles were made with dry-brush strokes, with those in the background beyond the trunk darkest. In painting the bare elms in picture number 5, the main trunks were painted with a round brush, and the tiny masses of twigs at the top executed with dry-brush strokes, with special attention to the radial lines of each mass. Finally, a very thin and light wash was used at the tops of each tree, to create the illusion of the splayed form—so characteristic of the elm.

The large, full-foliaged oak, in illustration number 6, is depicted with a rounded crown, heavy, gnarled trunk, and masses of rich leaf forms. When painting this tree, pay particular attention to the light direction and indicate this with modulating value contrasts, from the light to the dark sides. To produce depth and dimension, accent the masses of foliage on the far side of the main limbs with the darkest tone, as shown in this illustration.

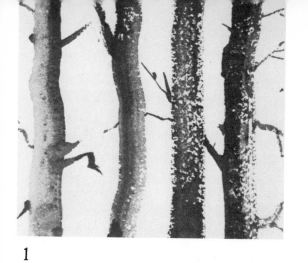

1

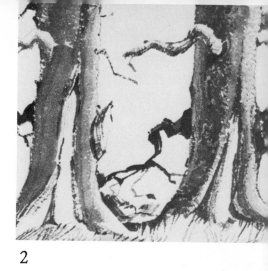

2

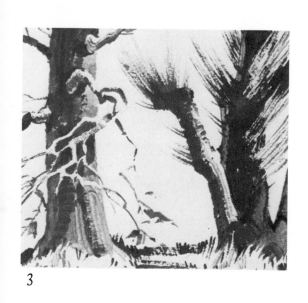

3

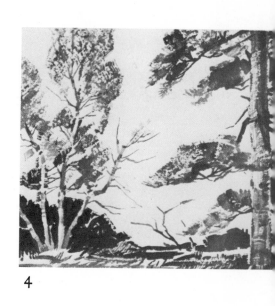

4

5

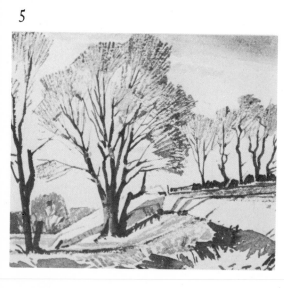

6

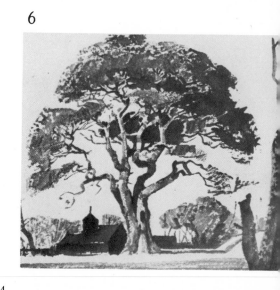

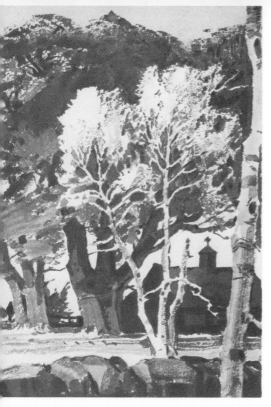

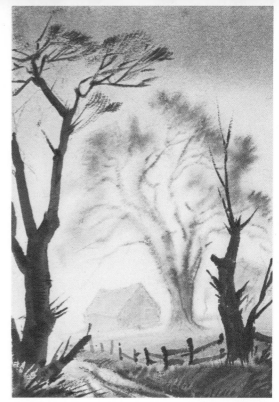

LIGHT TREE, DARK BACKGROUND TREE IN FOG

The presence of a light tree foiled against a dark background not only gives value accent to a picture, but adds interest as well. Students will find the practice of creating white silhouettes of trees by painting the dark forms behind them, a valuable training. With the proper value using dry-brush strokes on the edges, I painted in these dark forms *around* the silhouette of the whole birch tree—its masses, trunk and main branches.

Dry-brush strokes and wash accounted for the modeling of its foliage, trunk and the branches. For the smallest branches, a razor blade may be used to scratch out tiny white lines.

The next illustration presents a value contrast of another kind. Here, an enveloping fog obscures the details in the middle distance and background. To create this mood of nature, and

following the pencil drawing, wet the *entire* surface of the paper. Next, float a graded tonal wash for the sky, dark at the top, with the lightest value at the horizon. While wet, use the square-end brush to indicate the masses of the elm's foliage with pigment (with scarcely any saturation). Fan out these strokes lightly, following the direction of each foliage mass. The blurred effect will be instantaneous.

While the surface of the paper is still slightly wet, paint the trunk and branches. For the smallest branches use a brush with a fine point. The barn, ground plane and road are painted next in that order. Finally, when the paper has dried completely, add the dark tree forms in the foreground with a round brush loaded with pigment.

If you experiment with this method and

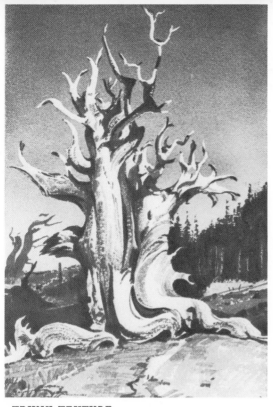

TRUNK TEXTURE

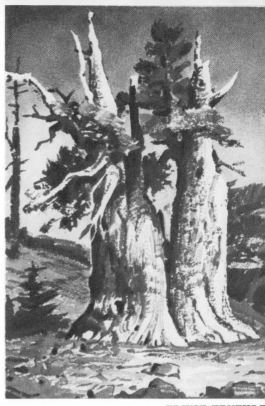

TRUNK TEXTURE

find your paper dries out too quickly, this can be remedied by adding a little glycerine to the water; this will retard the drying. Other methods for remedying this situation: *soak* the paper in water before painting or place a wet blotter under the dampened paper. This will keep the paper moist for hours. One other hint—you can re-wet any area after it has dried completely, using a brush lightly. This will give you another start on the newly wet surface.

The illustration above (number 3) represents a dead tree trunk of a Sierra juniper, at the timberline. (The usefulness of the dry-brush stroke used in painting this form has been clearly demonstrated on page 22, plate number 6.) The order of painting this picture is as follows: (1) a well-studied pencil outline with careful regard for rhythms and pattern; (2) the trunk, limbs and branches silhouetted against the sky, covered with liquid rubber (latex); (3) the sky area brushed in with a graded wash over the entire surface and when dry, the latex removed, leaving the tree form in clean outline; (4) the background trees painted in the darkest value as shown; (5) the juniper tree painted with dry-brush strokes, first the darkest values, next the middle values, and finally, the lightest values—leaving passages of white paper to indicate the high-lighted areas, especially in the base of the trunk and in the top branches. The second juniper tree above was painted without the aid of latex. The sky wash was worked around the simpler pattern of this tree, and the balance of the picture painted in the same order as the first. Foreground was painted last.

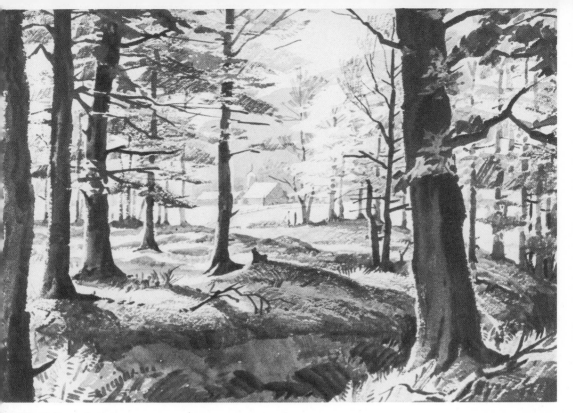

VIEW FROM FOREST

THE FOREST

In painting pictures with forest motifs, the artist must organize his composition with special care. Out of the welter of details such a subject presents, one must select only those features which lend themselves to an artistic arrangement. This is especially true in the spacing of the trees, the variety of their scale, and the rhythm of their vertical movements.

Another important consideration is to provide an "optical pathway" for the eye to travel—either from the inside of the woods looking out (as pictured in the first illustration above) or, from the outside looking in as in the case of the illustration at the top of the next page. Returning to the first picture, notice the close-up of the tree on the right;

how much it helps to create scale and by contrast with the other trees in the middle distance and background, a feeling of space depth.

Reflected light may be seen on the tree trunks and in the bank in the foreground. This may be warm or cool, depending on the object which is reflected into a shadow area.

Dry-brush strokes (and by this I mean a brushful of pigment with little saturation) were used to model the edges of the glittering light passages.

In this first picture the darkest values in the foreground were painted first; next, the middleground; and finally, the background hill, with a thin wash. In the latter I left white paper to indicate the sunlit meadow, the illuminated

VIEW INTO FOREST

tree at the edge of the woods, the tops of the barns, and in the immediate foreground, small masses of fern and grasses. Where the background values came up against the dark of the trees, I left a tiny valley of white. This created the illusion of space around each tree. The second watercolor, looking into a pine forest, shows the foreground trees lightest in value, as these are receiving the brilliance of the sunshine from the right side. As the other trees in the middle and background recede in space, their forms become less definite and the values darken. Depth has been achieved by the sunlit foreground, the dark shadow of the middleground, and the medium dark of the background. The order of painting this picture was as follows: (1) the far stretch of the background was indicated with a medium dark tone; (2) the darkest value was used next to create the shadow area of pines, leaving white paper for the vertical shafts of those trees accented by sunlight; (3) foreground trees were modeled, using dry-brush strokes where necessary; (4) pine twigs and small branches were scratched out of the dark with a razor blade; (5) foreground shadows and underbrush were painted with swift strokes, to produce texture and an effect of strong sunshine.

Finally, look for the "optical path" that compels you into the depth of the forest, by the open passage formed by the crown of the dark trees in an "S" form movement.

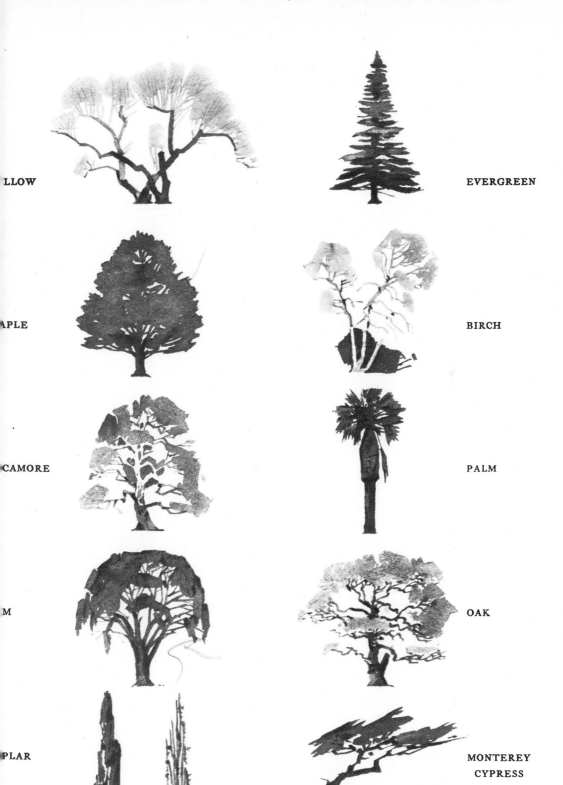

LLOW

EVERGREEN

APLE

BIRCH

CAMORE

PALM

M

OAK

PLAR

MONTEREY
CYPRESS

29

TEN VARIETIES OF TREES

In seasons when a tree is devoid of foliage, its basic structure of trunk, limbs and branches is most clearly seen and may be studied to advantage. It is on this framework or skeleton that its leafage grows. From early spring when the buds sprout into tender leaves to the mid-season when the foliage reaches its full growth, the color changes are gradual. Similarly, when fall comes, trees like the oak, maple and elm turn in their somber green coats for a new raiment of dazzling hues, until at last the season changes again, the leaves fall, and nature's cycle is completed.

The ten varieties of trees included in this book have been selected from three major sections of the United States—New England, the Far West, and the South. No attempt at survey has been made in this restricted group; instead, I tried to include familiar trees which are often found in contemporary landscape paintings.

The willow, tracing its ancestry from Biblical time and mentioned in the Psalms, is one of the most romantic of trees. Its picturesque form is usually encountered along narrow waterways, millstreams, and in meadows.

Evergreens, which is the common term for the pine, fir, spruce and sequoia, are found in many sections of the country on the mountains and hills, as well as in the lowlands. Their hardy forms could not be neglected here, nor could I bring myself to eliminate from a general list the graceful poplar and aspen, and the rugged picturesqueness of the Monterey cypress.

A New England landscape, especially in the fall, is unthinkable without the brilliance of the maple. Neither could the birch be overlooked, with its slender white trunks and branches accented against a dark background.

The sycamore was selected for its decorative character, the trunk of which has a mottled pattern, like the hide of a Dalmatian. It is frequently found along creek beds, where mingled among other trees, it creates an arresting pattern. Its limbs have a lightning-like quality.

Palm trees are associated with antiquity especially with Egypt and the Nile. In the semi-tropics of our farthest Southland they grow along the shoreline of the coast, where their rhythmical trunks and individual foliage form dominate the landscape. Winslow Homer, frequently regarded as our greatest watercolorist, included the palm in many of his paintings made in the Bahamas.

The stately elm. How often this tree has been featured in our American literature and in our landscape art! Threatened with destruction some years ago by the Dutch tree blight, but miraculously saved by an alerted conservation program, its graceful quality is undeniably linked with our urban as well as our rural heritage. The chestnut tree has been irretrievably lost to the American scene.

And now, finally, we include two varieties of oak—the Northern oak and the live oak of the South. Picturesque and powerful in form, the Northern oak is a dominating motif in all seasons. Formidable in appearance, it cannot be ignored. The live oak, with its dripping Spanish moss, is as much a landmark of the deep South as the graceful architecture of the Old Dominion.

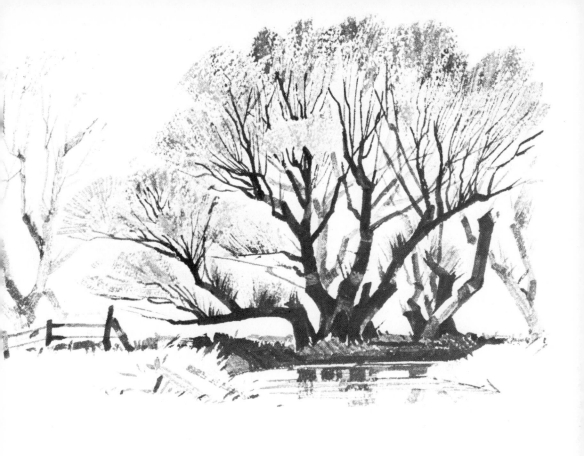

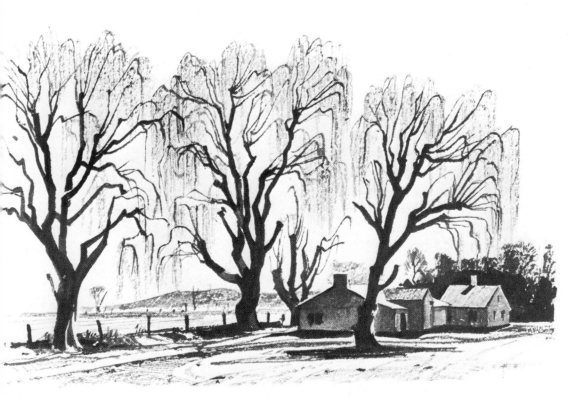

THE WILLOWS

When out sketching in the country, the artist often encounters the graceful willow growing along creeks and river banks where the soil is moist. Or from the vantage point of a hilltop he can see rows of them, decorating a curving stream as it winds into the distance. Of the several varieties, the white willow is the largest. Often several heavy limbs are found growing together, forming a thick dark mass at their base. This is illustrated in the examples found reproduced on page 31, at the top.

In the illustrations on the opposite page, at the top, are shown the white willow without its foliage (on the left); and next to it, the same tree with its full leafage. Below these, in the same order, is shown the weeping willow.

Note that in the white willow the small branches and twigs project upward, while in the weeping willow, the terminal twigs grow in long drooping spirals producing its mournful expression – and hence, its name.

In spring, the willow leaf is a tender green-yellow, gradually turning to a silvery green in summer. In winter, its branches have a yellowish tone, providing an attractive note in contrast to snow and the deep brownish color of its textured trunk.

The technique for painting the white willow without foliage is as follows: first, make the usual but carefully drawn pencil draft; next, paint the darkest value of the trunk and main limbs; and then, the medium values with the square-end brush; when dry, take a finely pointed brush saturated with color and drag it lightly over the rough texture of the paper with a quick succession of strokes, to indicate the modeling of the thin branches. The lacy character of the branches may be easily seen in the illustration and accounts for its typical form. The texture of these strokes is shown below.

The order of painting the same tree in full leafage is started first with the square-end brush, modeling the forms with dry-brush strokes, and again, light enough in pressure to deposit the pigment irregularly on the top of the rough paper surface. While these areas are still wet, the branches and limbs are indicated, and finally, the dark trunk. The weeping willow forms were painted in the same manner. When the tree is without foliage, work from the trunk upwards – first the trunk, next the main limbs, and lastly, the lacy formation of the twigs. Full foliage is painted advantageously from the top down.

To demonstrate even more clearly my general remarks about these two willow varieties, turn back to the simple compositions on page 31.

The one at the top, showing a clump of white willows reflected in a stream, represents this variety in a common circumstance. With their heavy trunks darkest in value at the base, and their foliage growing in radial movement from the branches, the sprawling design of the overall pattern has great interest. Below, a group of weeping willows is seen silhouetted against the light sky, with the winter tracery in marked accent. Note how effectively the low horizon and group of farm buildings have forced the eye to return from the vertical lines of the trees to the horizontal movement of the ground plane.

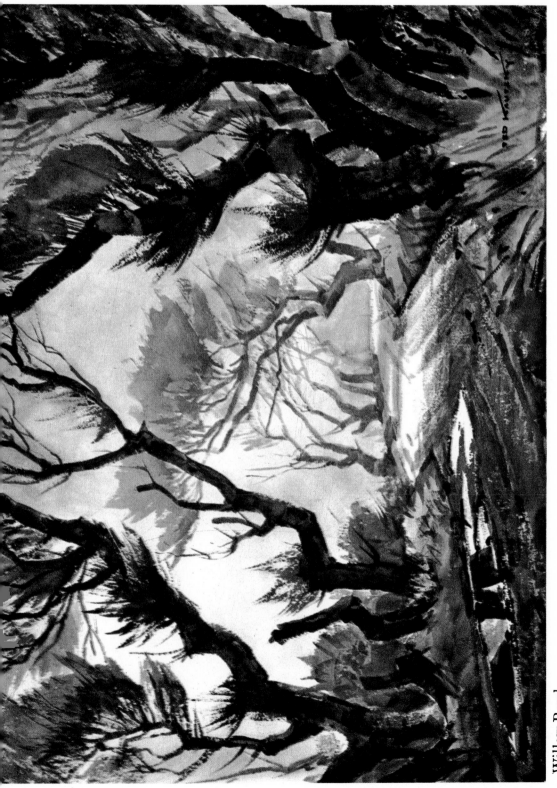

Willow Road

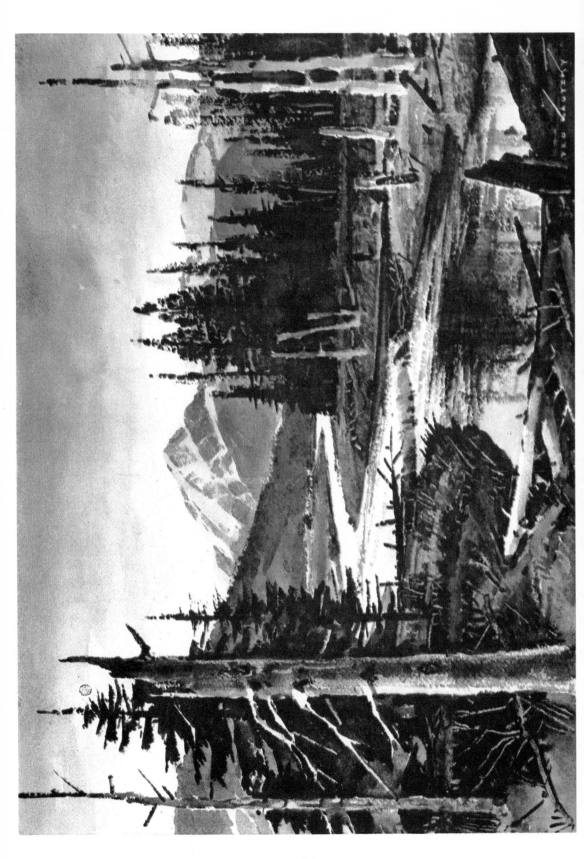

34

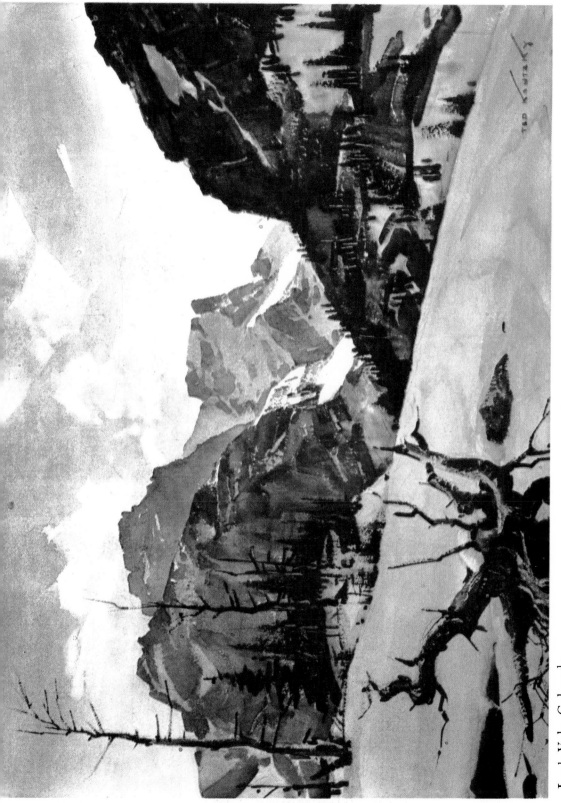

Loch Vale, Colorado

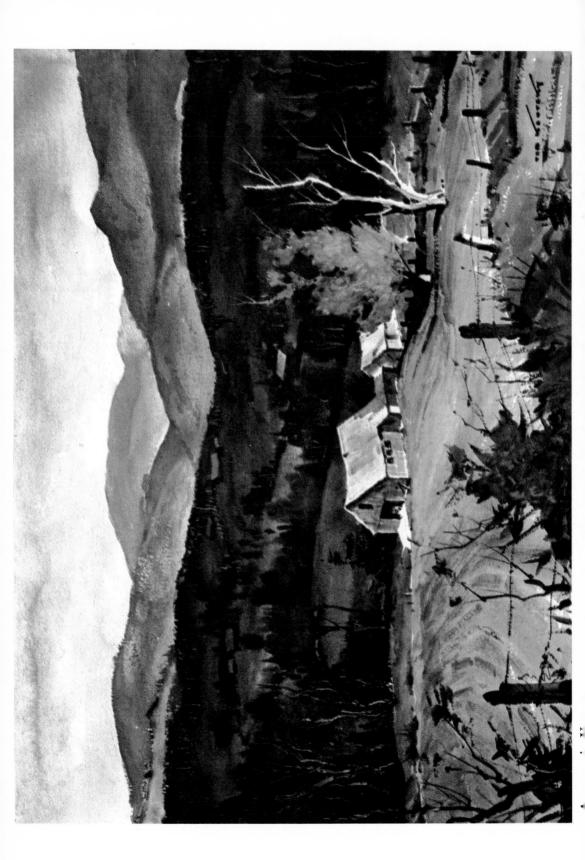

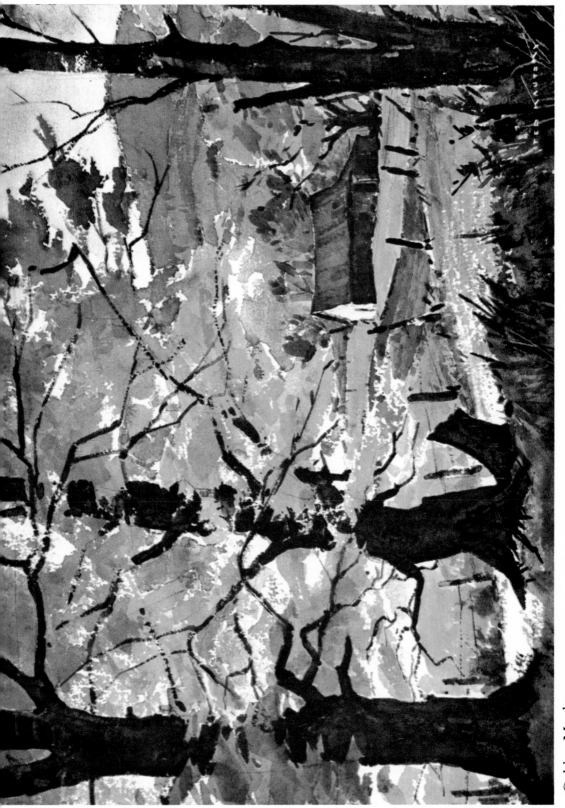

Golden Maples

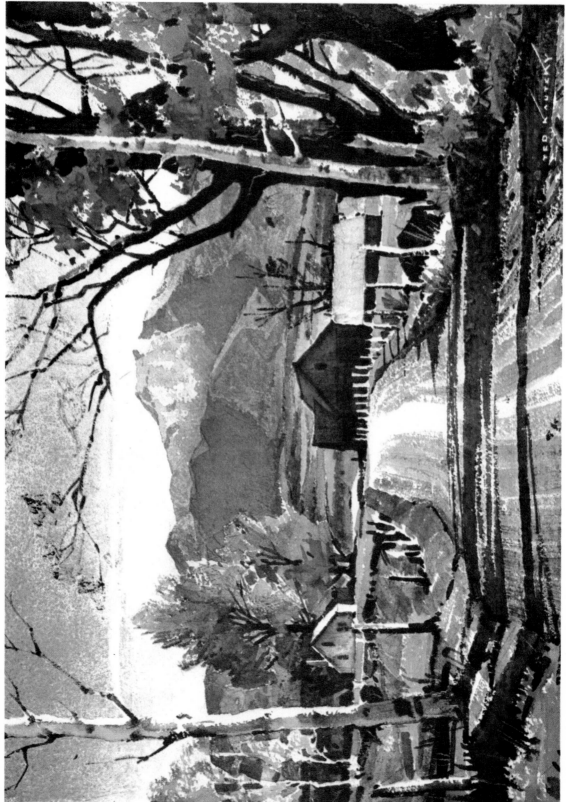

Along the Road in New England

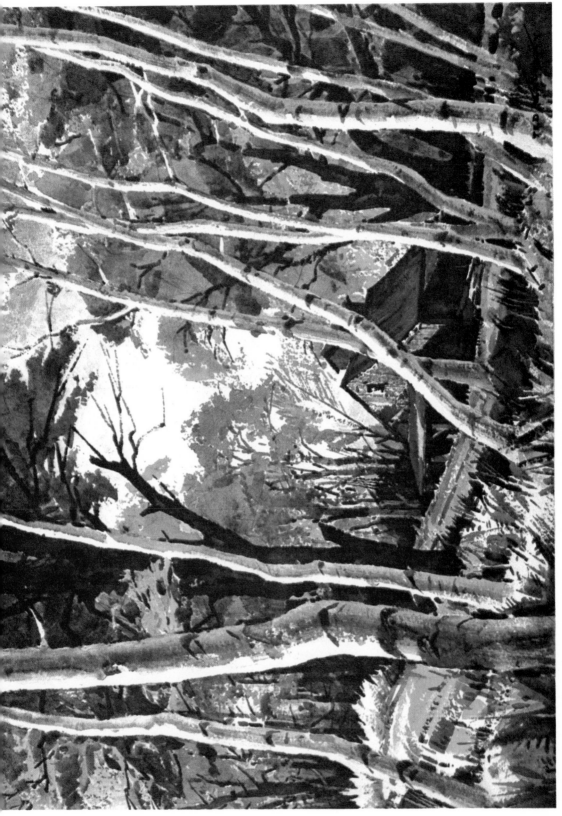

Birches at Forest's Edge

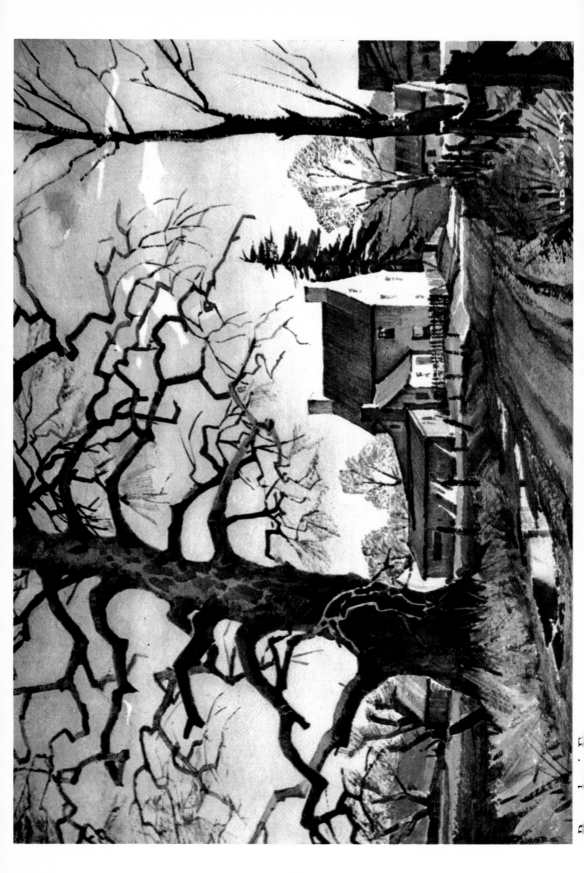

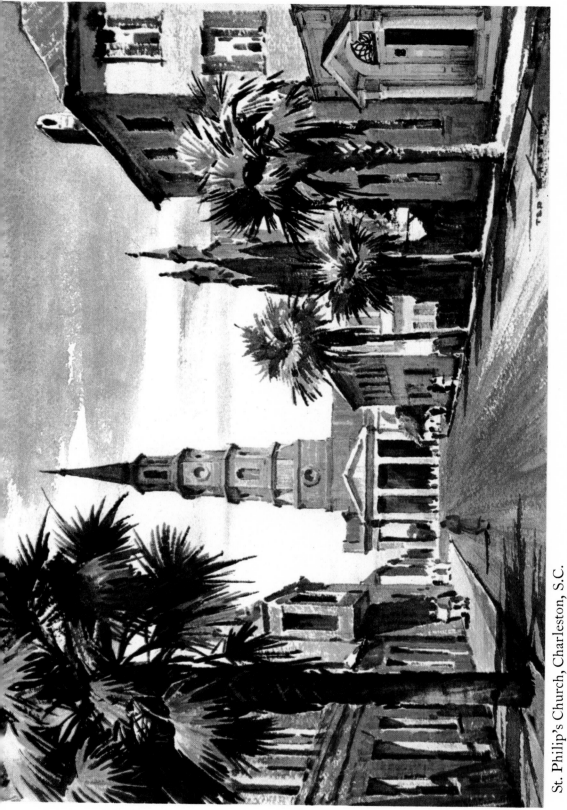

St. Philip's Church, Charleston, S.C.

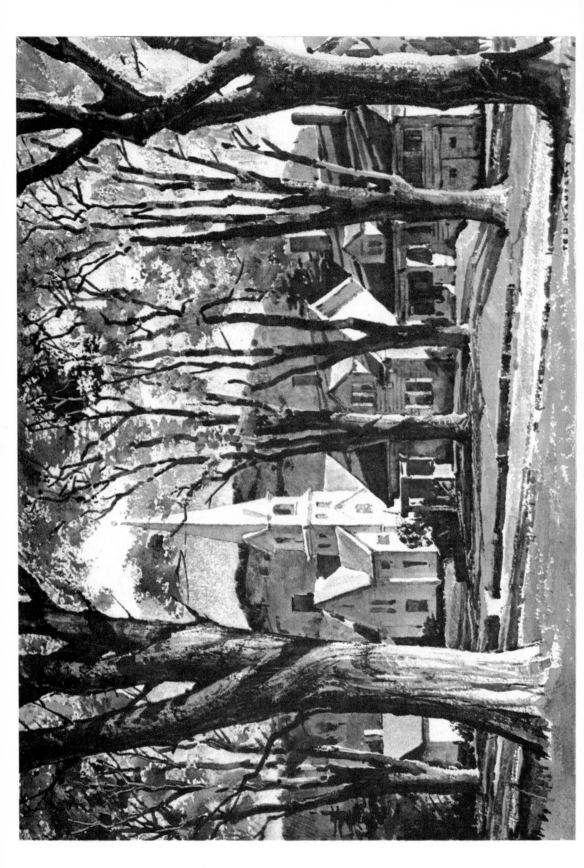

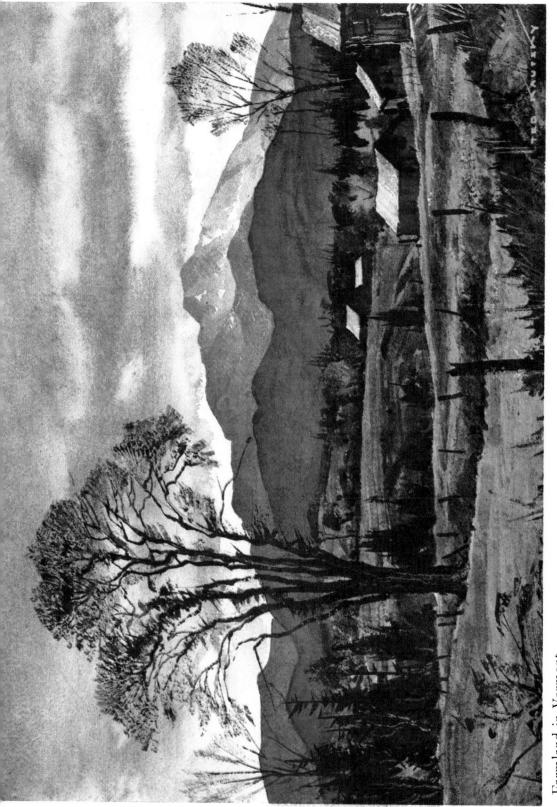

Farmland in Vermont

43

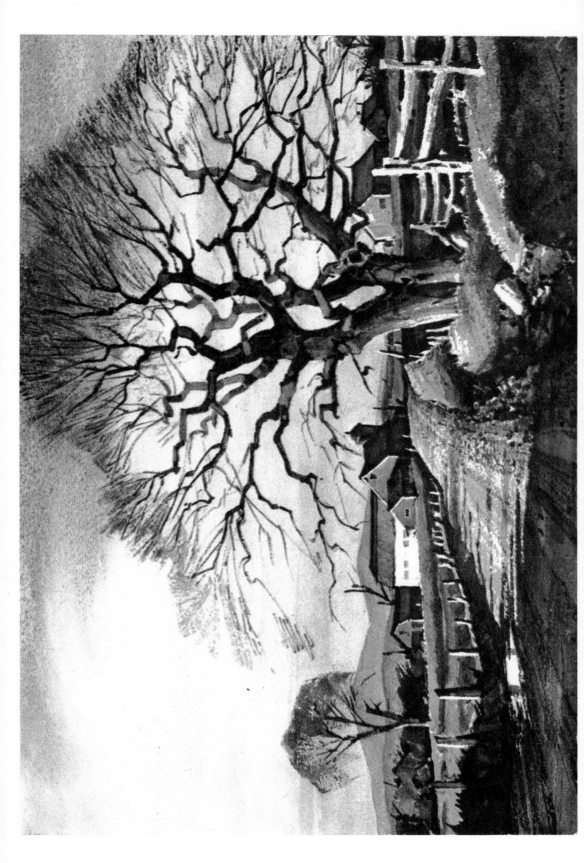

Spanish Moss

45

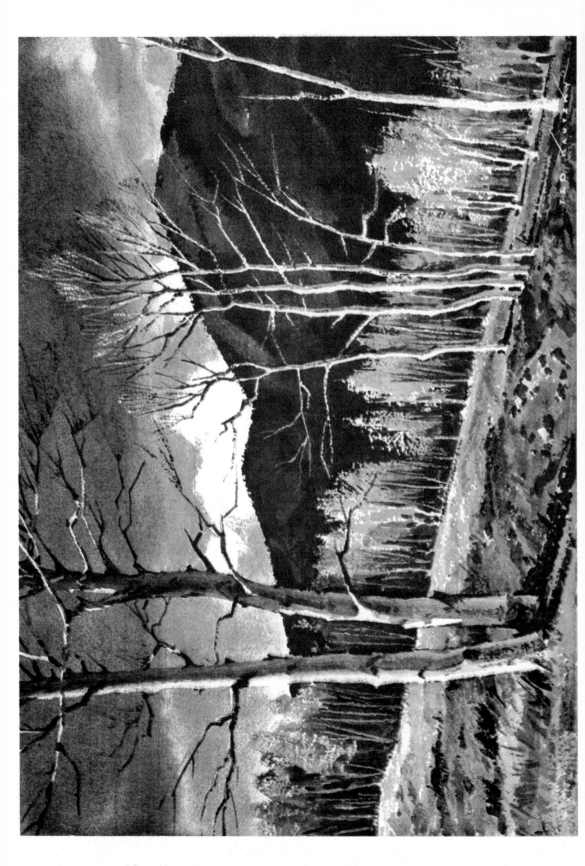

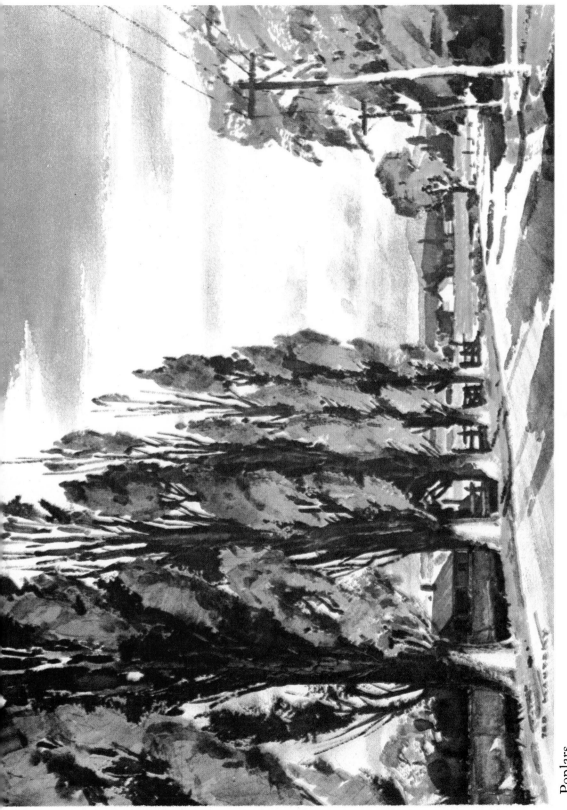

Poplars

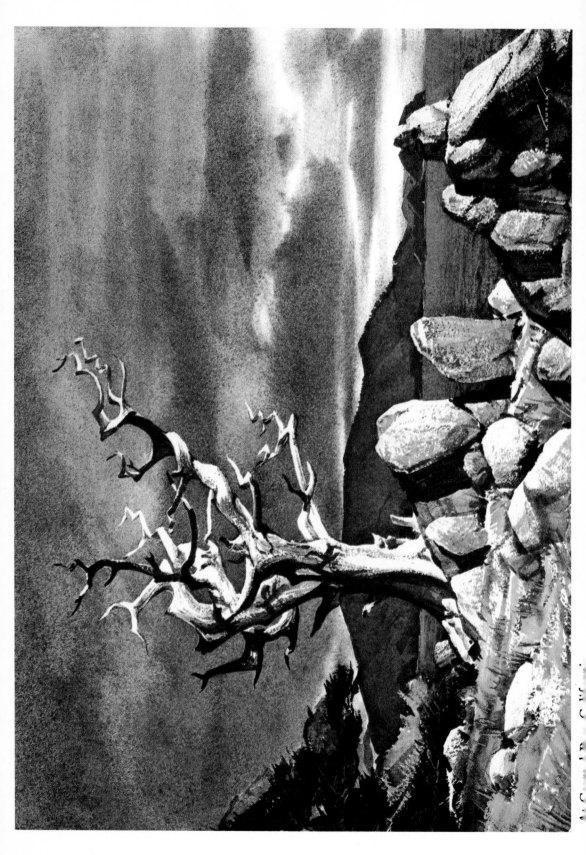

48

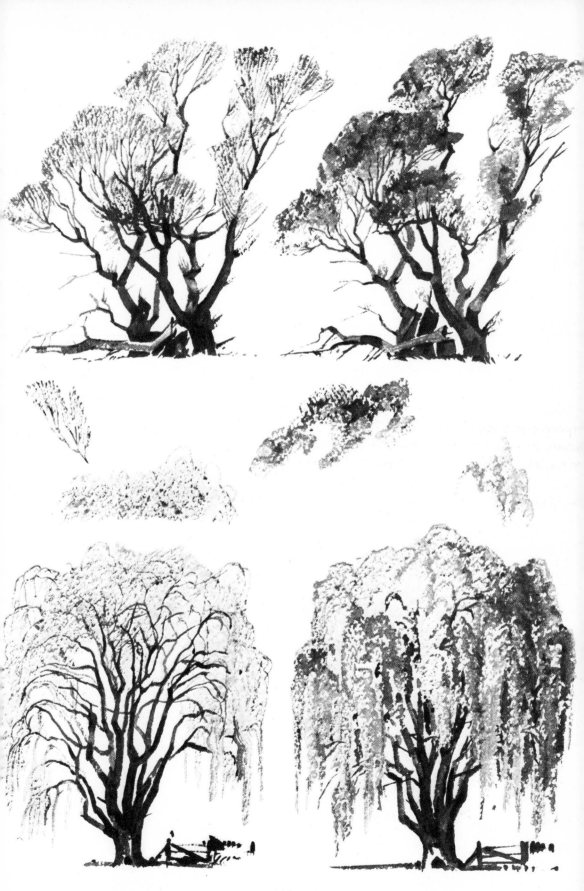

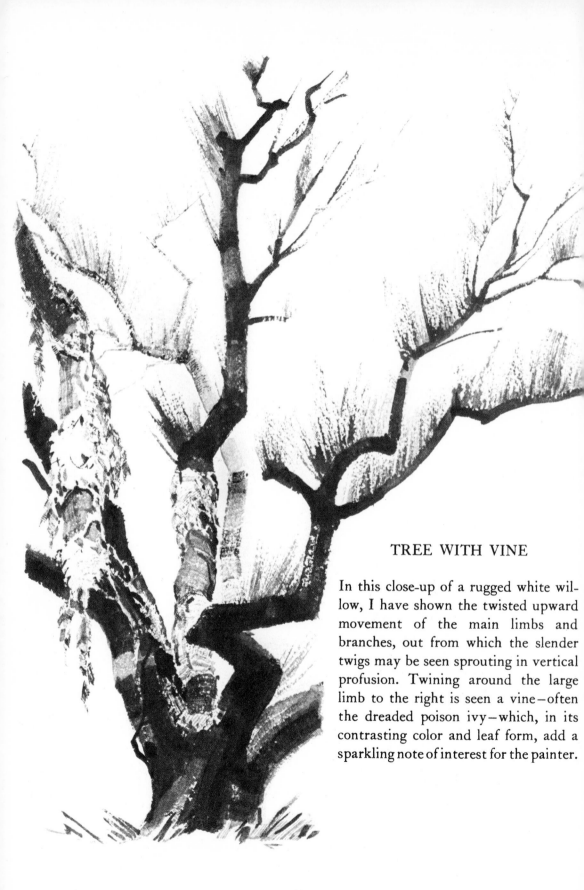

TREE WITH VINE

In this close-up of a rugged white willow, I have shown the twisted upward movement of the main limbs and branches, out from which the slender twigs may be seen sprouting in vertical profusion. Twining around the large limb to the right is seen a vine—often the dreaded poison ivy—which, in its contrasting color and leaf form, add a sparkling note of interest for the painter.

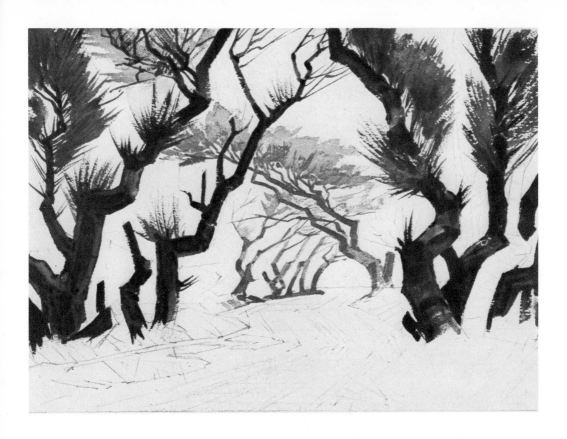

WILLOW ROAD

The arrangement of my watercolor *Willow Road*, reproduced in color (p.33) and shown above in a partially finished state, has been composed with an off-center triangular arch of dark trees. The forms of the dark foreground willows create an interesting pattern of oblique movements with those in the middle plane in counterbalance. The misty color of the prevailing atmosphere is enhanced by the mud puddle in the left foreground, which provides a sparkling accent of value contrast.

For paper, I selected a full sheet (22 by 30) of medium rough D'Arches, which I described on page 6 as being off-white, and ideal for this type of atmospheric picture. My palette was set with a restricted, but carefully chosen group of fine colors, namely: Burnt Umber, Raw Sienna, French Ultramarine Blue, Davy's Gray and Hooker's Green No. 2. The order of painting this picture was as follows. The dark tree trunks in the foreground were laid in first with direct strokes as dark as I could make them, without losing transparency of color. Next, the road and bushes in the foreground were related in color and tone. To create the illusion of the incoming fog and at the same time to produce the proper color and value, I subdued the green-yellow in the middleground by an admixture of Davy's Gray.

The sky area was painted at the very last with spontaneous strokes, leaving white patches here and there. A thin wash was applied at the horizon to soften and blur the forms, obscured by the mist of the fog.

EVERGREENS

The Eastern White Pine is a stately tree, conical in shape, with a brownish-gray trunk tapering gradually from the base. The branches, growing horizontally from the trunk, support the long, blue-green needles which grow in clusters. The crown is irregular. In painting this tree, brush in the main masses of the foliage leaving the trunk white paper. While these passages are still damp, model the edges of the foliage with a fine-pointed brush, and when dry, complete the form of the trunk and branches.

To obtain the three-dimensional form of this, and all other trees, remember well that the branches and foliage grow (see plan, opposite) *around* the whole trunk—not, just left and right. This is shown clearly in the small illustration in the center, to the right.

Next, the Alpine Fir. This tall slender tree, growing at the timberline, often attains a height of 100 feet and terminates in a Gothic-like spire. Its foliage, also blue-green in color, is made up of small needles. The trunk has an ash-gray color.

The White Spruce grows from sea level to altitudes of 5,000 feet. Like the Alpine Fir, it has a straight central trunk, pyramidal crown, and its thick heavy branches sweep gracefully toward the ground. In color it is similar to the fir. To paint the spruce, or fir, draw the general silhouette in pencil and indicate the middle values of foliage with horizontal brush strokes. When dry, paint the dark values of foliage and trunk. To produce light accents on the trunk, wet the area with a brush allowing the paint to dissolve, then *press* out the desired form with the *flat* side of a knife—but do not scratch the surface.

The Limber Pine is found in high elevations on exposed rocky slopes, ridges and canyons. At the timberline, it resembles a dwarf shrub, often grotesque in form. Needle clusters are dark gray and green; the trunk, silver-gray. Paint the dark upright trunk, giving special emphasis to the reflected lights; next, the horizontal trunk, crawling along the ground, with dry-brush strokes; lastly, the foliage, with the pointed brush.

The Sierra Juniper illustrated here (and also the two examples on page 26) grows in high altitudes in dry, gravelly, or rocky soils in the mountain region of the Far West. Many are only 20 to 30 feet in height with a short, abruptly tapering trunk, often divided into two or more thick forks to form a low broad crown. Their enormously large surface roots ramify into the dry, rocky soil.

Here, the foliage of the crown was painted first, using dry-brush strokes on the edges, leaving white paper for the sunlit and windswept limb. The trunk was indicated with darkest values first, again in the "dry-brush stroke technique," and finally, the details of foliage and branches were modeled.

The tremendous scale of the Giant Sierra Sequoia shown in the illustration in contrast to the house and other trees is not exaggerated.

The fluted trunks of the Sequoia are reddish-brown and the foliage, a warm dark green. Paint the masses of foliage first with dry-brush strokes, next the dark value of the background forest, modeling the giant trunk last.

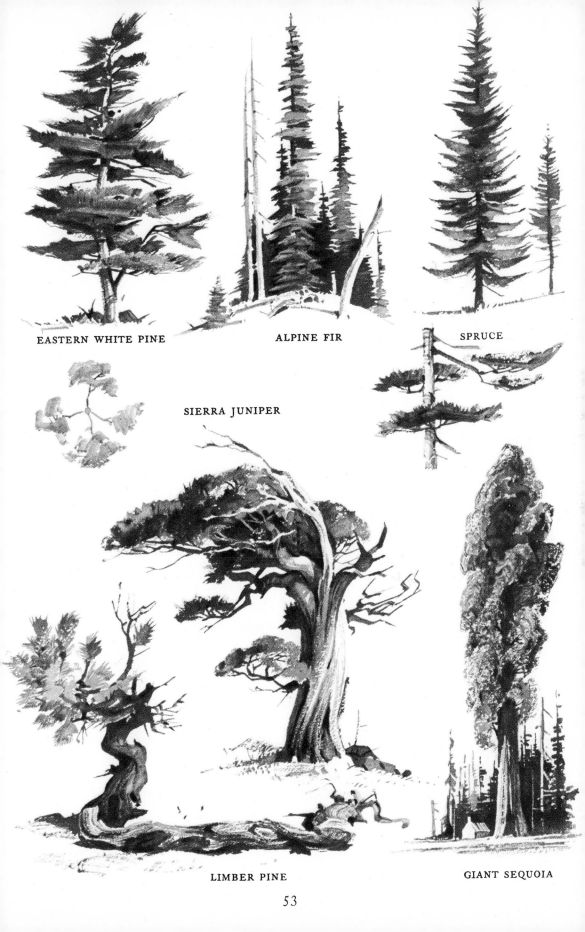

EASTERN WHITE PINE

ALPINE FIR

SPRUCE

SIERRA JUNIPER

LIMBER PINE

GIANT SEQUOIA

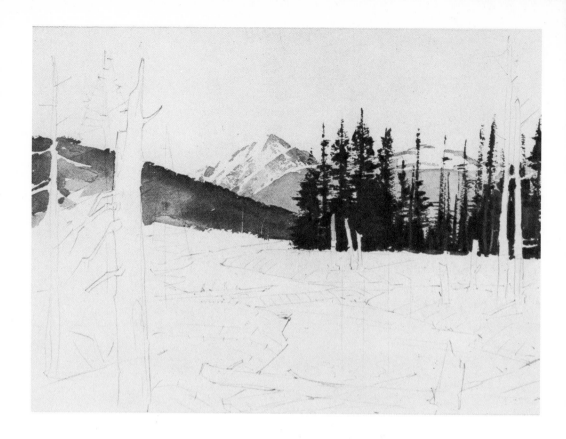

GRAND VALLEY, COLORADO

Grand Valley presented in full color on page 34, and above, in its skeleton outline with the first important patterns brushed in its background, is more of an open composition than *Willow Road*. In the present watercolor, the winding stream leads the eye to the point of interest (the snow-capped mountain).

The linear structure easily seen above, is an "S" form lying down, in the long perspective route of the stream. Note the placement of the disappearing watercourse in the distance and the mountain peak—both off-center. Further, the light, restful horizontal cloud forms accentuate the depth of the sky.

The original, measuring 15 by 20 inches, was painted on a half sheet of medium rough Royal Watercolor Society paper. Burnt Umber, Raw Sienna, Cobalt Blue, French Ultramarine Blue, Hooker's Green No. 2 and Alizarin Crimson made up my palette.

To achieve the particular effects desired, first the snow-covered mountains were painted. Secondly, the hill covered with trees in the left background was painted, and then the evergreens to the right were laid in with dry-brush strokes, followed in order by the middle distant meadowland, and the evergreens and river bank to the left—leaving the dead trees white paper, which, when the surface was dry, were modeled with emphasis on their cylindrical shafts.

The water reflections and right bank were brushed in and finally, the sky. The use of warm foreground colors achieved the illusion of great distance.

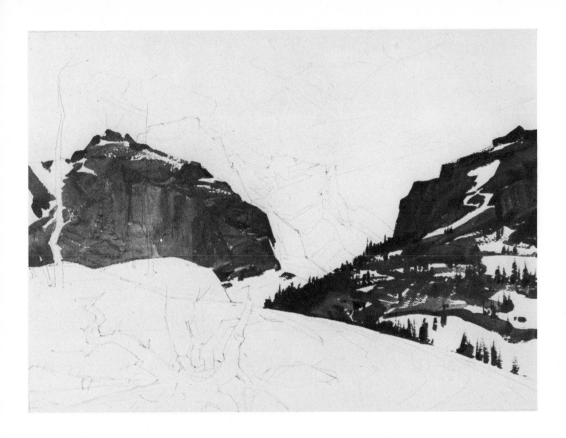

LOCH VALE, COLORADO

The focal point of my watercolor *Loch Vale* (p. 35) is placed off-center, concentrated on the snow patterns in the mountain peaks. The overall design is made up of angular forms, in which the large mountain mass on the right is counterbalanced by the tree trunk in the foreground, and further—by the slant of the snow bank, from left to right side.

A full sheet (22 by 30 inches) of medium rough D'Arches paper was used in painting this picture. My color scheme was evolved from a palette of French Ultramarine Blue, Cobalt Blue, Cerulean Blue, Alizarin Crimson, Raw Sienna, Burnt Umber and Hooker's Green No. 2.

Following the pencil pattern clearly seen in the illustration above, I first painted the dark mountain form on the right side with direct, spontaneous strokes, leaving patches of white paper to represent snow patterns. Later these were qualified in value and color to effect shadows and distance. The mountains in the background were painted next in succession, from the nearer one to the farthest sunlit peak. Note the reflected light effect on the shadow side of farthest jagged snow peak.

Now the snow patches on the mountains and the snow bank in the foreground were painted with the proper washes. The dark accents of the foreground tree trunk and middle distant pines were indicated with spontaneous strokes. At the last, the square-end brush was used for the sky washes, leaving light paper patterns for the clouds.

THE MAPLE TREE

One of the most attractive trees for the painter is the sugar maple, especially in its New England setting in the fall season when its dense leafage turns into a blaze of color—rich yellows, bright orange and red. Because of its closely-woven foliage it makes a good shade tree.

When seen growing in the open, this maple has a short trunk and a symmetrical, rounded crown. From its central trunk, its limbs grow in an upward movement as seen in the illustration opposite, at the top, right side. In forests, the maple has a long trunk and a relatively small crown. See illustration. In the fall, when its leaves begin to drop, it sheds its foliage from the topmost branches first, gradually "undressing" to the bottom! This condition of partial fall raiment is particularly interesting to paint, for it creates a contrasting pattern of bared branches and rhythmical layers of colored leaves. Turning to the illustrations opposite we find first, the maple fully covered with foliage in its usual contour. Only a few "sky holes" appear, revealing a pattern of branches in dark shadow. To paint the maple in this state, make a well-studied pencil outline, noting first its general shape and then its supporting structure. Indicate the layers of foliage masses, remembering the advice about the foreground and background forms. Now, take up your square-end brush and start working at the top of the crown with spontaneous strokes—establishing the darkest values first. Continue the painting downward, using the dry-brush stroke technique to produce the soft edges and textures. While these areas are still wet, strike in the dark trunk and branches, giving special emphasis to the definite shadowed forms, which are shown in the illustration.

To paint this same tree without foliage, you will also need a pencil draft. Notice the rapid diminution of the trunk as it divides into a series of long limbs, which in turn, taper gradually to the outermost twigs. Using the edge of the square-end brush, indicate the trunk and main branches first in the dark values. Do not continue these strokes to the top, as the lacy character of the terminals requires a different stroke. For this pattern, you will find that modeling the fine forms in light, quick dry-brush strokes working inward from the outer edge will give you this desired effect. The painting technique of the tree in partial foliage, shown at the bottom, is a combination of the procedures of the first and second examples, and painted in the same order. Brush in the foliage forms first, then the dark shadowed trunk and limbs—and at the last, the same dry-brush strokes to model the top branches and twigs as previously described for illustration number 2.

When maples grow in a stand, as pictured in the forest composition opposite, they exhibit the longer trunk mentioned at the beginning of this chapter. In painting such an arrangement as this one, produce the background pattern of trees first, in the middle value as shown. Brush in the dark foreground tree and shadow next, and then the lighter-valued foliage in sunshine. Details of branches should be left to the last, taking care not to use more than necessary for an artistic design.

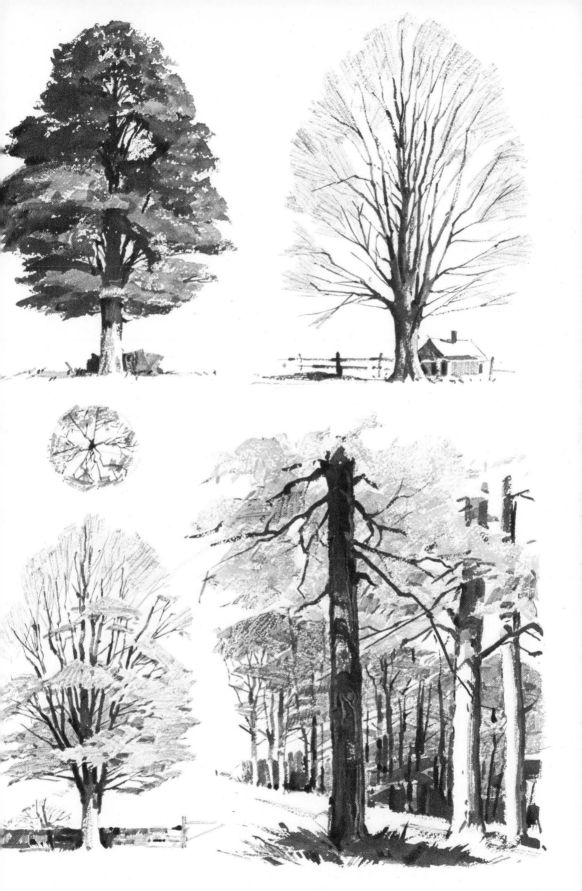

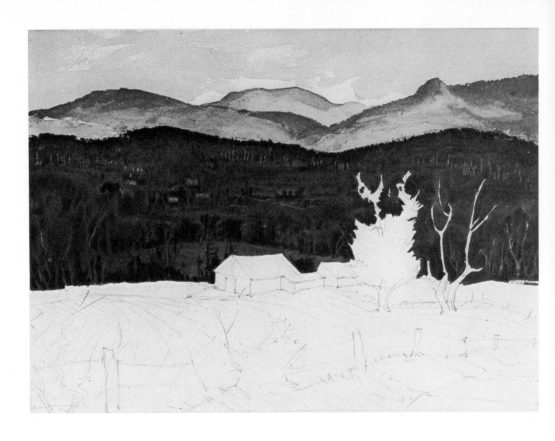

AUTUMN IN VERMONT

The arrangement of my watercolor *Autumn in Vermont* (p. 36) has a strong dark and light pattern.

A high horizon, with a series of rhythmical hill forms lead the eye to the deep foreground where the focal point of farm buildings, the "flaming maple" and the barren tree are silhouetted in light against this background. Further, the barbed wire fence descends gently from left to right in a winding curve, leading to the same principal motif. Brush strokes used in painting the sloping field accentuate the perspective.

D'Arches paper, 22 by 30 inches, in a medium rough surface was used.

The colors used were: Cobalt Blue, French Ultramarine Blue, Vermilion Red, Cadmium Yellow, Alizarin Crimson, Burnt Umber, Raw Sienna, Hooker's Green No. 2, and Aureolin Yellow. I painted the sky first with spontaneous wash strokes, and then began working on the pattern of sunlit, distant hills. The whole middle area in shadow was done rapidly with a very wet wash and plenty of pigment to model the darkest pattern of trees. While this was still damp, I modeled the rooftops of distant barns and tree trunks with the "pressed knife" technique described previously. Next, the red maple and barns were painted in the high key of bright sunshine. The foreground was now painted up to the edge of the curving fence line in the immediate foreground—and finally, the fore plane with its accents of dark fence posts and bush. I used a razor blade to produce the finest branches in the maple and dead tree.

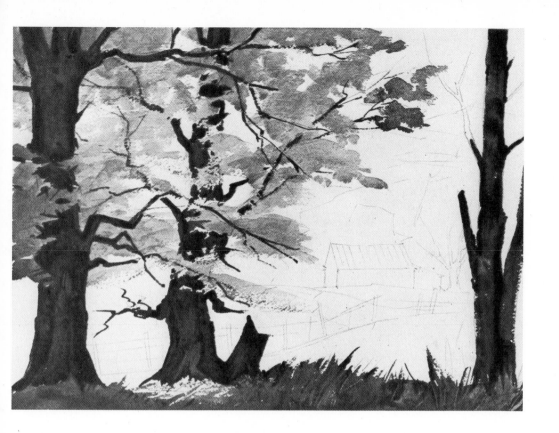

GOLDEN MAPLES

The brilliant autumn foliage of maples (p. 37) has an irregular pattern and shape, requiring a light, transparent quality of wash. Note that individual leaves do not count—only the masses. Again, I used D'Arches paper in the heavy 300 pound weight, and for this watercolor I painted on a half-sheet of rough surface, 15 by 20 inches.

My palette was composed of Cadmium Yellow, Aureolin Yellow, Raw Sienna, Burnt Umber, Alizarin Crimson, French Ultramarine Blue, Cobalt Blue, and Hooker's Green No. 2. In this reproduction, the largeness of the individual patterns makes it comparatively easy for the student to determine the color mixtures.

A rough pencil outline indicating the main masses only, preceded the paint-ing of the brilliant foliage. This action called for direct strokes, keeping the wash thin and taking advantage of the rough surface of the paper to create textures. My square-end brush was used on the flat side but without allow-ing its rapid strokes to make hard, mechanical edges.

When this foliage area was dry, the dark trunks and branches to the left were blocked in, followed by the im-portant foreground shadow, and the tree trunk at the right.

The illustration above represents the picture at this stage. And now in order: the barn, surrounding trees; the yellow sunlit hillside, distant hill, and sky. The white paper patches left around the edges of the foliage, create a brilliant light shimmer.

THE BIRCHES

Of the many varieties of birch, the most common are the Gray Birch and the Paper Birch. These are found growing singly or in clusters in northeastern United States. And although they prefer moist soil, we often find them along the edge of forests and in pastures.

The Gray Birch is usually not a tall tree. The crown is usually narrow and open with dark green foliage. Its bark is a grayish-white on the mature tree and has a rough and irregularly-broken surface of dark patches. In winter, minus its foliage, the lacy character of the tree is seen to advantage.

Although resembling the Gray Birch generally, the Paper Birch is a much taller tree. With age, its crown is broad and open with a few large limbs, and many horizontal branches and flexible twigs. Its paper-like bark has a chalky-white surface, broken with irregular, horizontal textures and dark scars.

On the opposite page, I have pictured the birch in several aspects, but in each case I have exploited its light trunk and branches by foiling these against a dark background of building or hillside.

The first illustration at the top, left, was produced by striking in the shadow side of the barn with a dark value, leaving a white paper pattern of foliage, trunks and branches. The foliage textures were modeled next with dry-brush strokes of the square-end brush, and the trunk and branches painted with a pointed sable brush.

It is a good practice in painting light colored trees to work the dark background *around* their forms, producing in the first instance a white silhouette. However, in the next illustration the advice just recommended could not be conveniently followed, as the interwoven trunks and branches would have made it a difficult task. To secure the same result, I resorted to the use of liquid rubber (latex), with which I painted in the forms. Following this procedure, I brushed in the dark background right over the latex pattern and when dry, rubbed it off—leaving the same kind of white silhouette I had created in the first illustration. Details of trunk and branches were modeled with a pointed brush, similar to the willow branches on page 49. .

In painting the cluster of birch trunks in the close-up (illustration No. 3) I again brushed in the dark background of the barn around the bases. When dry, I painted the trunks individually by wetting each trunk area with water and modeling the rounded surface with a moist brush loaded with pigment—working first on the right or shadow side of the tree. When each of these was painted and dry, I indicated the dark patches with dry-brush strokes; also the fine horizontal markings.

The last illustration shows a dark background in which are indicated a group of light trees in shadow, created by use of knife strokes worked in the damp area. The close-up of the birch to the right was painted in the technique described on page 19, except that in this instance, I was careful to get the pigment on the central group of hairs of the square-end brush, keeping the flanking ones saturated with plain water. A good, sure vertical stroke produced the resultant rounded trunk form, on which was worked the dark textures and scars.

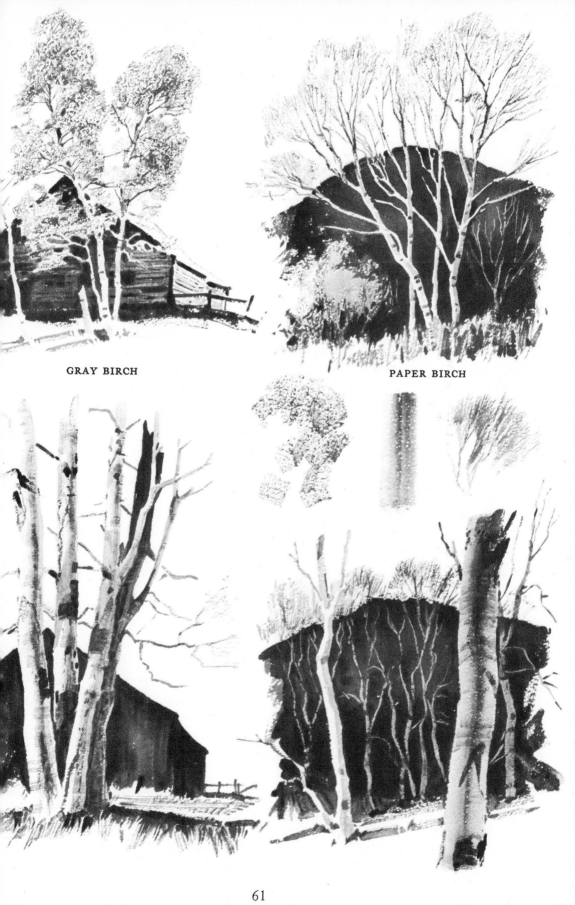

GRAY BIRCH

PAPER BIRCH

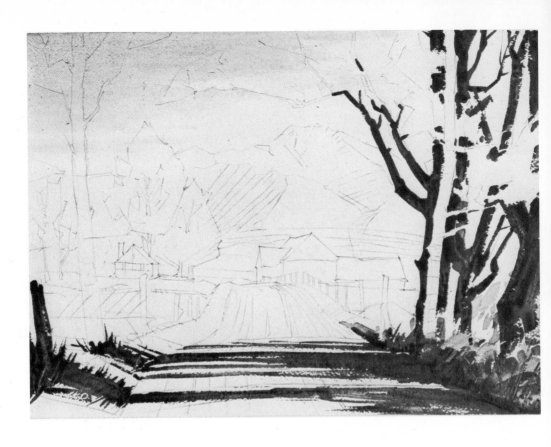

ALONG THE ROAD IN NEW ENGLAND

The strong verticals of trees in the foreground left and right (p. 38), connecting by powerful horizontal shadows, form a natural frame for the focal point. An informal balance has been achieved by the greater number, or mass, of trees on the right, with the geometrical form of the barn accenting the middle distance. The perspective lines of the road leading into the picture increase the depth. My paper—D'Arches, 300 pound, medium rough—was used in a half-sheet, 15 by 20 inches. Aureolin Yellow, Vermilion Red, Alizarin Crimson, Raw Sienna, Burnt Umber, Hooker's Green No. 2, Cobalt Blue, French Ultramarine Blue, and Cerulean Blue formed the palette for this picture.

I began the painting with the sky area. A graded wash was used, leaving the light passage of clouds over the mountain peak the white of the paper. Then coming immediately to the foreground, the mass of trees to the right was brushed in along with the horizontal shadows. The illustration above represents this stage. Next, the mountain was painted, again leaving the pattern of trees and barn white paper, and then this area was painted in turn. Moving to the foreground once more, I modeled the large sunlit birches, the foliage, and the road itself—all with dry-brush strokes.

Notice the "drag" edges produced by the dry-brush stroke, especially along the high-lighted surfaces. Also, the tone of the sky, darkest at the top, left, and lightest at the right, indicating the direction of the illumination.

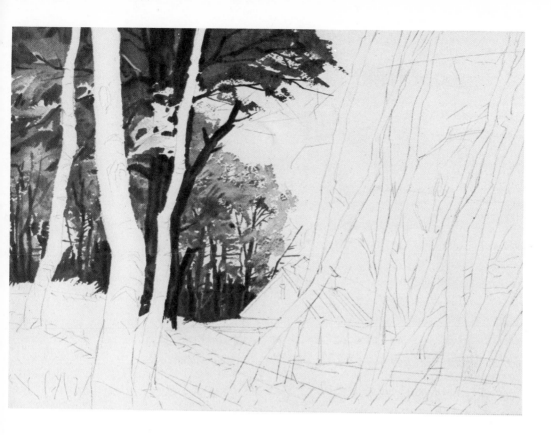

BIRCHES AT FOREST'S EDGE

The rhythmical pattern of these graceful trunks (p. 39), forming a strong vertical accent, dominate the watercolor. Space depth was realized by receding scale of the tree trunks. Dark middle and background forms provided a natural foil for the luminous birches. This contrast is particularly evident on the left side, where the slender birch is completely silhouetted against the dark tree trunk.

Again, I used a half-sheet of D'Arches in the rough surface, 300 pound weight. My colors were: Aureolin Yellow, Vermilion Red, Alizarin Crimson, Raw Sienna, Raw Umber, Cobalt Blue, French Ultramarine Blue, and Hooker's Green No. 2.

I began with the darkest tones first, blocking in the middle distant tree mass to the left; then the background trees that fall behind the shed of the sugar house, also to the left. At this point in my painting, the design of the values is represented in the monochrome illustration above. Notice that the three vertical birch trunks on the left are white paper silhouettes. Continuing the background passages, I painted the sugar house and trees to the right. The shadows on the house exhibit warm reflected lights, which I have accentuated here.

The sloping ground plane was modeled largely with vertical strokes to indicate the grasses, with the largest scale of these in the foreground. Finally, the important forms of the birches were modeled in the manner previously described on page 60.

THE SYCAMORE

The sycamore is a massive tree with a tall trunk and a wide-spreading crown. Its branches reach out in all directions at sharp angles from the trunk, twisting and turning in short and long curvatures. The trunk, usually large at the base and tapering quickly, is dark brownish-green at the base. This color changes to a lighter, mottled and decorative pattern, finally becoming a glistening cream color, decorated irregularly with dark blotches.

Found east of the Mississippi, except in Florida, the sycamore is a picturesque tree under all conditions—and especially, when it is seen dominating a landscape scene.

To paint this tree, begin by making a well-delineated pencil sketch of a particular sycamore—like the one shown opposite, at the top to the left. With the flat side of the square-end brush, start with the crown and work downward, keeping the surface lively, the strokes spontaneous. Let the white paper form the pattern of the trunk and limbs by working around their forms with the background masses, intercepting them here and there to indicate the nearer foliage.

To produce the necessary depth and dimension, superimpose the dark accents of shadowed foliage. Now, model the base of the trunk with a middle value and add the final details. Observe in this illustration the worth of the dry-brush stroke in handling the edges of the foliage masses.

Painting a sycamore without foliage requires a reversal of the procedure outlined above. Here, I recommend starting at the massive trunk base and working upward, using a "juicy" brushful of pigment, and graduating the value scale in conformity with the tapering movement of the trunk. Strike in the limbs and branches last, creating the lacy character of the outermost twigs with dry-brush strokes. To secure the effect of foreshortened limbs and branches, vary the pattern of lights and darks as represented in the illustration. The close-up of a typical sycamore, illustrated to the right, has been presented to show the structure of its sturdy base and the decorative character of its spotted bark. The twisted limbs are clearly shown, as they create a lively movement towards, and away from, the observer. In this situation, some limbs are dark (in shadow) and others are light, but all affected by the direction of the sun, which, in producing cast shadows, helps to model the form of the trunk, limbs and branches. In painting this illustration, I first wet the surface of the trunk. Into this saturated area the color was floated in, and simultaneously, the rounded form of the trunk was roughly modeled. While this was still damp, I modeled the start of the connecting limbs.

After these washes were dry, the dark accents of shadows were added, and next, the modeling of the light-colored limbs and branches. A dark, superimposed wash was used to "anchor" the base and to produce the mottled character of the spotted bark surface.

The lightest and finest branches and twigs were done with a small, round sable brush, using scarcely any water, "dragging" the strokes lightly over the rough paper.

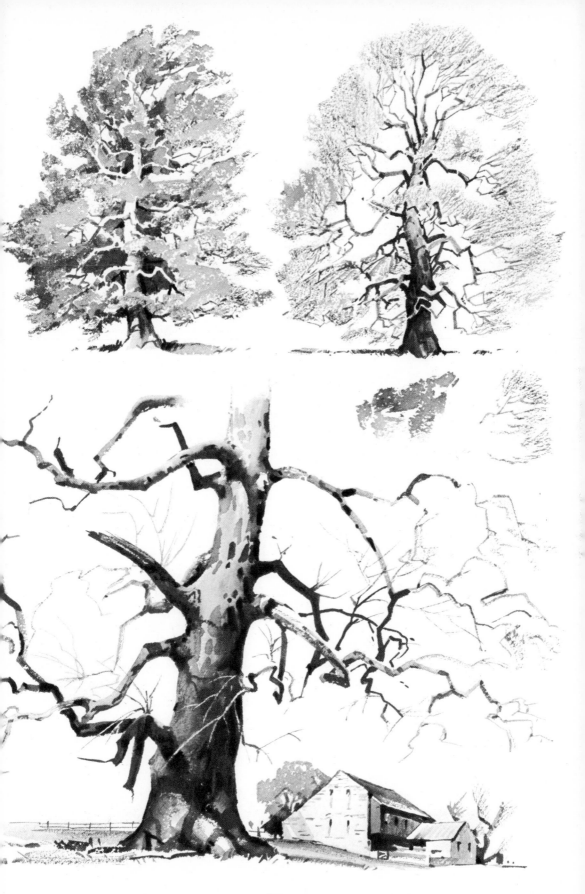

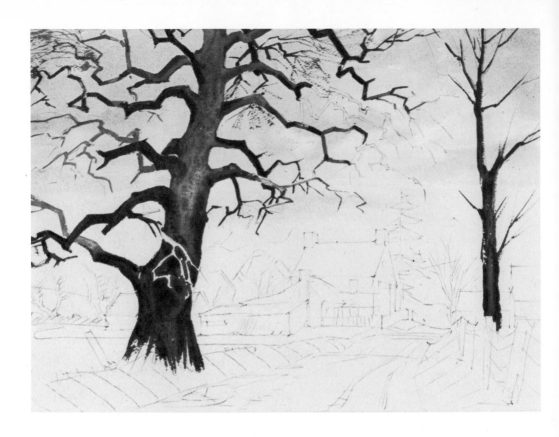

PENNSYLVANIA FARM

In this watercolor (p. 40), I exploited a low horizon to give dominance to the massive sycamore on the left silhouetted against the sky, and balanced on the right by a smaller vertical tree. The architectural forms provided a stabilizing contrast to the active movement of the sycamore's branches.

The dark pine accents the sunlit side of the farmhouse at the focal point, as do the perspective lines of the road and fence. A puddle in the left foreground added a note of interest.

My paper was D'Arches, 300 pound, in the medium rough surface, 15 by 20 inches. Eight colors were used, as follows: Cobalt Blue, French Ultramarine Blue, Raw Sienna, Aureolin Yellow, Burnt Umber, Hooker's Green No. 2, Alizarin Crimson, and Vermilion Red.

My order of painting began with a light wash in the sky area. Next, I painted the large sycamore on the left, in the manner described on page 64; and then the dark vertical tree on the right. Background hill, dark pine, farmhouse, and barns were then indicated, followed by the distant field and trees. The strip of middleground in sunlight was left as a white paper area in this stage of the painting. Then, the shady foreground of field and road was indicated, leaving untouched the water pattern of the puddle. At this point, with my value scale well established, I went back to work on the middleground bathed in strong sunlight, using high-keyed color, in thin washes. Finally, the puddle and the dark pattern of the fence to the right were brushed in.

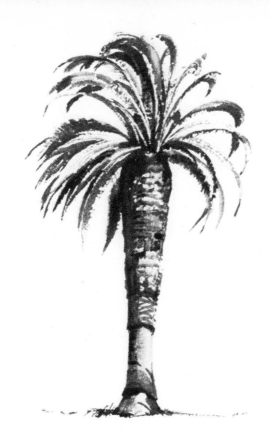

THE PALMS

The palm tree has been associated with the ancient world centuries before Christ, largely through the cultivated art of the Egyptians and Babylonians. In the United States, this decorative tree grows in the semi-tropics of our Deep South, where it is used for its attractive appearance in gardens, parks, and along avenues. Apart from its ornamental grace, its leaves supply the natives of the tropics with thatch for the roofs and walls of their houses; mats, fans and hats; and from certain species, come food in the form of coconuts, dates and oil.

In general, the palms have strong central stems from which the leafage grows radiantly to form graceful crowns. Those that display a fan-shaped leaf belong in one group, among which the palmetto is a well-known example. Others have the feather-shaped leaf and belong in the second category. The Royal palm and coconut palm are of this variety.

For the artist who delights in painting in the semi-tropics, these forms are an important part of his knowledge. His practice in painting them will lend authority to his efforts.

In the illustrations on page 68 I have shown a close-up view of these two major leaf forms—the fan-shaped on the left, representing the palmetto; and the feather form of leaf of the Royal and coconut palms, on the right.

To paint the form of the palmetto leaf, I recommend using the round, pointed

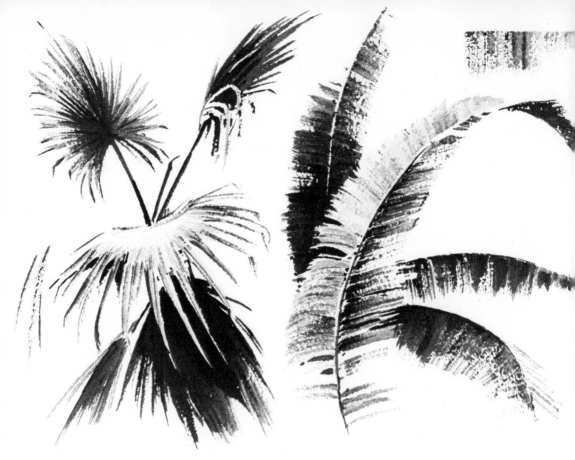

PALMETTO LEAVES COCONUT PALM LEAVES

brush and modeling the form from the center of growth outward, "lifting" the rapid strokes at the terminals to produce the pointed ends.

For the feather-like form on the right, I used my square-end brush working from the center of the stem outward with a series of dry-brush strokes in close formation. To produce a light form of leaf against a darker one behind it (as shown), I used the pointed brush to outline the lighter leaf.

On the opposite page, you will find a number of characteristic palm trunks. The one at the bottom, in the center, is shown here to represent stage 1 in the painting of a trunk. First, the trunk area was brushed in with clear water,

and while wet, a vertical stroke with the brush full of pigment modeled the shady side as seen below. Note that the extreme right side has a lighter value due to reflected light from the sky, sunlit ground, etc. In the one at the top, the tree trunks were modeled in the same procedure; to indicate the texture of the trunk, dry-brush strokes were used on a dry surface.

The illustration at the bottom, to the left, shows the typical form of the dead leaves clinging to the trunk of the palmetto in a closed, umbrella-like fashion. To the far right, I have pictured the characteristic basketwork texture of the remnants of dead and dried stubs, below the crown.

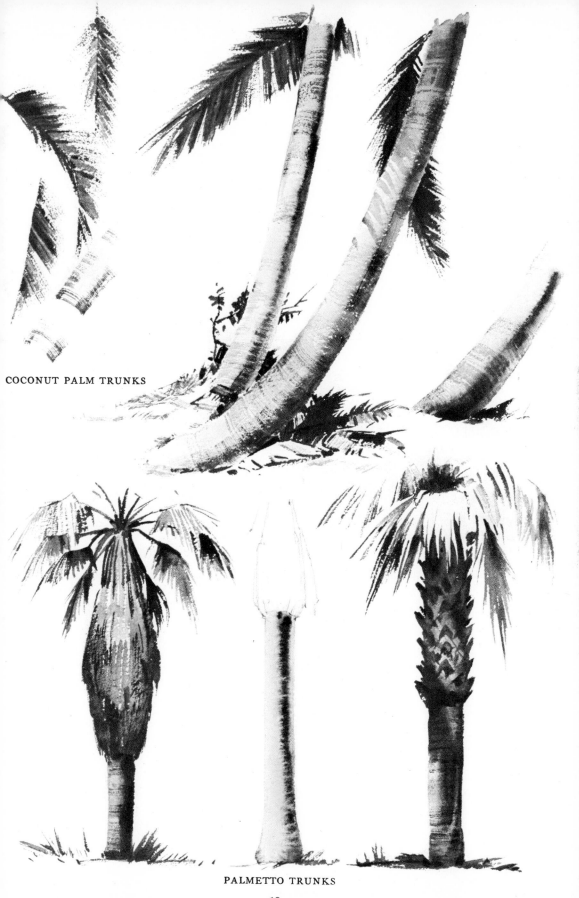

COCONUT PALM TRUNKS

PALMETTO TRUNKS

THE PALMETTO

To paint this tree in large scale, as shown in the illustration opposite, I recommend that the student pay particular attention to the following: first, the general form that has a fairly heavy trunk, from the top of which the stems, holding the foliage, grow in long radiant movements from the center; next, to observe the three-dimensional aspect of the crown, wherein the masses of foliage in the front usually appear as light forms against the dark ones behind them; and finally, the important silhouette forms that tie the whole tree together.

With these facts in mind, make a rough pencil drawing in outline, indicating the strong bi-symmetrical character of the whole form. Start the painting with the darkest pattern of the foliage, working around the sunlit leaves. Now paint the trunk in the manner described on page 68.

The small illustration, to the right of center, shows clearly the construction of the stems growing out from a central pivot. Notice the perspective of each fan-shaped mass of foliage.

The other small illustrations indicate the necessary simplified forms as each, in turn, becomes smaller and smaller in scale.

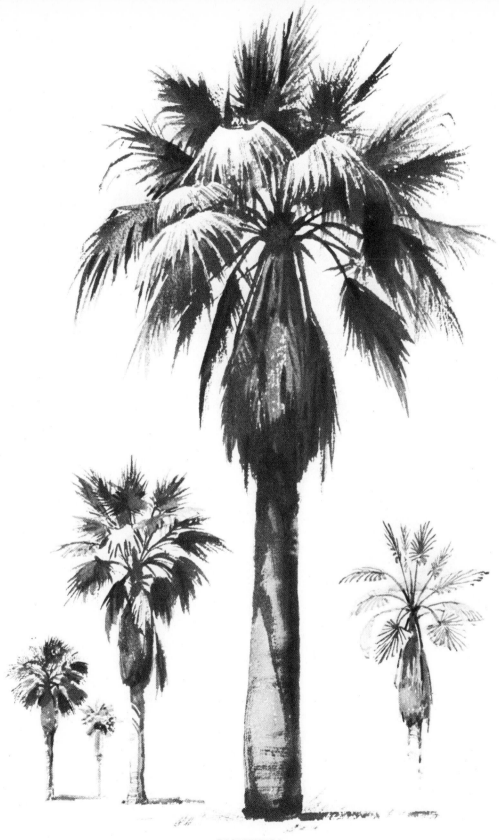

PALMETTOS

71

THE COCONUT PALM

The Coconut Palm is one of the most outstanding species. With its tall slender trunk, flared at its base and bending in a long curve to its wind-swept crown, the overall effect is truly majestic. Its leaf forms, like long feathers, sway outward and downward in gentle sweeps, as pictured in the illustration.

In the large palm, you will see the important use of the dry-brush stroke and the effective accents of high-lighted leaves. The use of a low eye level throws this group of trees into dramatic prominence.

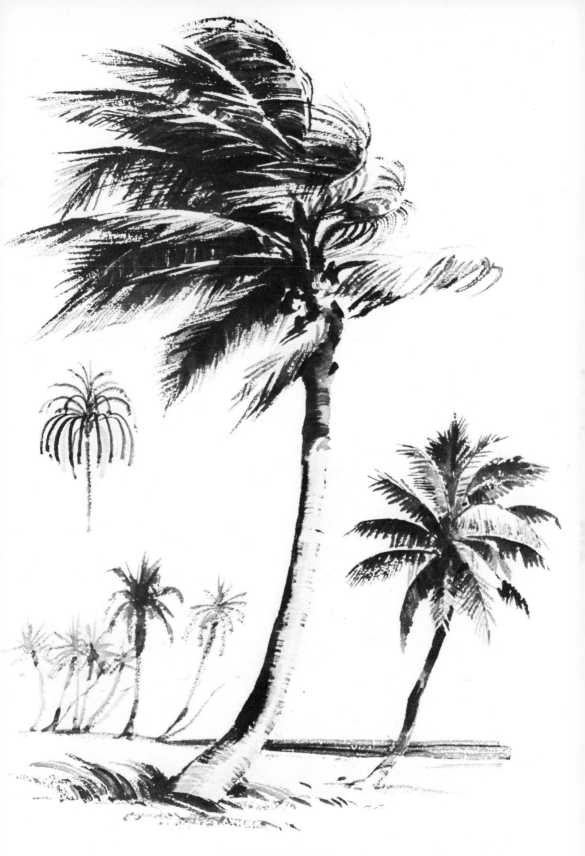

COCONUT PALMS

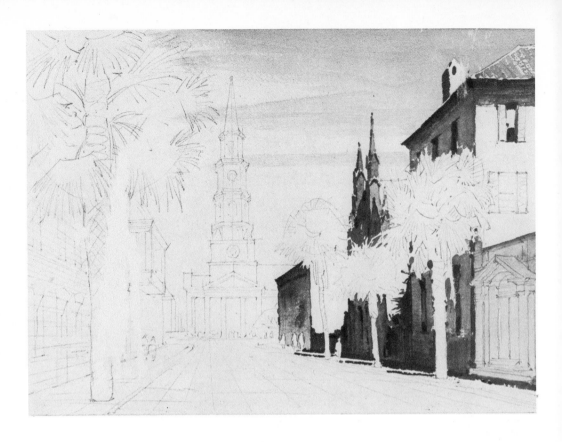

ST. PHILIP'S CHURCH, CHARLESTON, S. C.

As you can easily imagine, most times of the day and night, this thoroughfare (p. 41) was crowded with people and traffic. My pictorial concern was not with traffic but with the architectural forms converging on the motif—St. Philip's Church. To achieve this effect, I left automobiles out of the picture.

In design, this picture is composed of geometrical, vertical masses of architecture, relieved by the counter forms of the palmettos and the restful horizontal of a simple sky. Perspective lines of road and buildings lead the eye to the façade of the church, where the strong sunlight has accented the white pillars of the portico against its shadowed background.

My paper—D'Arches, 300 pound, medium rough, in size, 15 by 20 inches. The palette contained Vermilion Red, Cadmium Yellow, Raw Sienna, Burnt Umber, Hooker's Green No. 2, Cobalt Blue, French Ultramarine Blue and Alizarin Crimson.

My order of painting began with the sky with the slightly darker value at the top. This, I might add, was never touched again; its spontaneous brushwork satisfied me. Next, the shadow side of the buildings on the right, leaving the palmettos a pattern of white paper. Now the left hand palmetto in the foreground, worked from dark to light; then the buildings on the left, bringing me to the important focal point of the church, which was completed with special regard for its scale; and at the last, the trees to the right, the street and the figures.

THE ELM TREE

Throughout New England the elm is a favorite tree. Its graceful form, attractive in all seasons, has a nostalgic flavor, since it is so often identified in the memory with the quiet way of life of our historic villages. In these places, the elm often lines the streets with its crowns on either side intermingling, forming a natural arch and gentle shade. Its structure is V-shaped, with its heavy limbs and branches tapering in gradual diminution to form a round-shaped crown. In summer, its foliage is dark green, changing to the cadmium hues in the autumn. Barren of leaves in the winter the graceful proportions of the elm exhibit themselves in their stark tracery.

In the diagrams on the following page, at the top, I have purposely avoided painting a portrait of a particular elm. Instead the whole emphasis here has been placed on (1) the skeleton structure in line, showing general form of trunk, main branches and a two-dimensional (flat pattern) of the foliage masses, and (2) a value arrangement of light and shade in simplified form to show the light, medium dark, and darkest tones. These masses of foliage in light (at the top of the crown, left) receiving the strongest illumination, gradually darken on the right hand side away from the source of light, and in those under the roof of the crown, the value is darker still. Altogether, this scheme accounts for dimension, scale and volume. By keeping this principle in mind when you are painting the elm, you will avoid the error of lumping all of the foliage masses into a tangle of dark color, without regarding the fact

that it has a three-dimensional aspect. Now we come to the street scene at the bottom of the page following. Here I have described in *graphic* terms, a New England village street with rows of age-old elms, casting long shadows from the afternoon sun across the road, and onto the faces of the houses on the right. Notice the scale of the trees in the foreground; see how those in the middle distance and background diminish in value and girth.

In painting such a watercolor composition as this, it is advisable to start with a well-planned pencil sketch with full regard for the perspective, for this not only affects the architecture, but the road, fences, and trees as well. Now begin with your color and paint the elms in the foreground—first the foliage, then the limbs, and last, the trunks.

Working back into the depth from this foreground, you must graduate the values of the trees and shadow sides of the houses to account for the receding plane. The only exception to this general rule is in spots where deep shadows are found separating one form from another —as may be seen in the group of tree trunks in the left center, cast in shade by the bulk of the house; or the small figures in middle distance—a dark accent against the sunlit fence.

Study of this picture will explain more clearly than words how important it is to reduce foliage and branch forms to a simplified statement. Another thing: try to make your first stroke a final one —both in shape and value—as each superimposed stroke reduces the transparency and freshness, and gives a labored appearance to your watercolor.

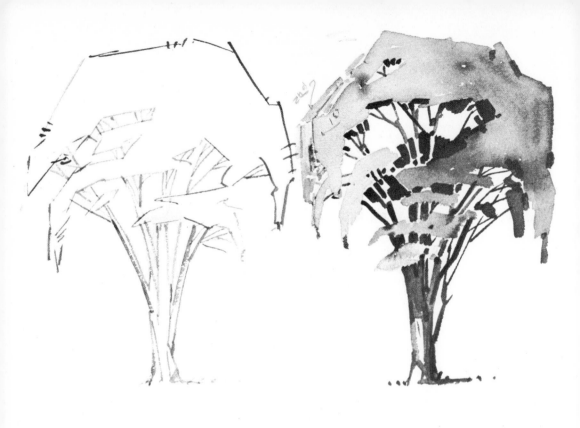

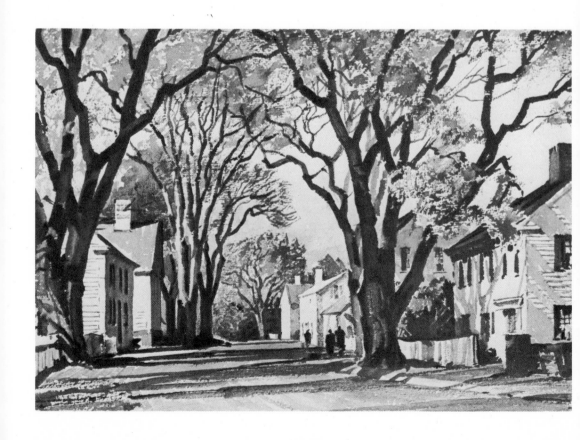

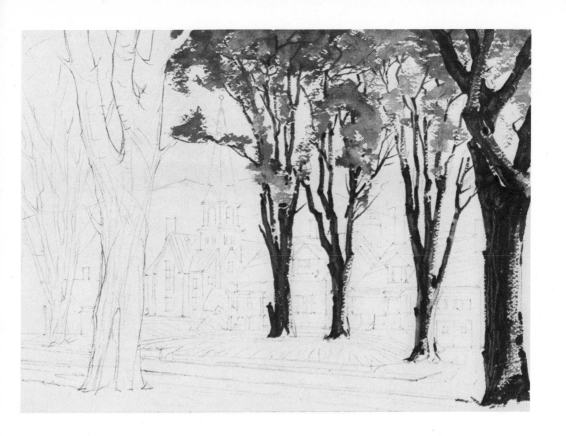

NEW ENGLAND VILLAGE

My watercolor *New England Village*, shown in full color on page 42, required special attention in the spacing of the trees. In order to secure depth and at the same time to stop the horizontal-like movement of the road, I introduced the large tree in the left foreground. The little white church, naturally framed between the opening of trees and foiled against the middle value of the soft contoured hillside is the focal point.

The active design of vertical branches made it patently unwise to introduce a billowing series of cloud forms. Instead, I resorted to a simple oblique streak which provided a quiet background and at the same time, made a counterbalance for the road. The paper used was D'Arches, medium rough surface, 300 pound weight, 15 by 20 inches. The colors—Cadmium Orange, Aureolin Yellow, Raw Sienna, Vermilion Red, Raw Umber, Alizarin Crimson, Hooker's Green No. 2, Cobalt and French Blues. I painted the picture in the following order: (1) the autumn foliage with the flat side of the square-end brush working downward and modeling each form rapidly; then the trunks and branches; such was the stage seen above; (2) the buildings—anticipating the strong reflected lights; (3) the background hill; (4) the foreground with its large tree on the left, and the road; (5) the sky—brushed in around the steeple and branches to form an accenting value for the white areas throughout the composition.

Note especially the reflected light in the shadows on the trees and the houses.

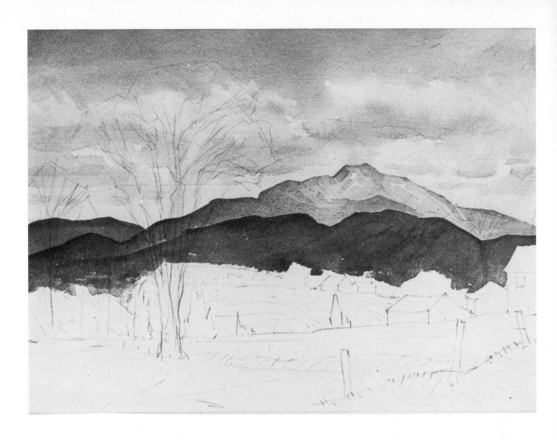

FARMLAND IN VERMONT

The design for my watercolor *Farmland in Vermont*, reproduced in color on page 43, is made up of a series of zigzag movements, which begin in the immediate central foreground following the edges of ground planes until they culminate in the farthest mountain peak. As a counterbalance for these long horizontals, the dominant vertical of the large elm on the left, plus the lesser one on the right frame the accent of the mountain peak. Further, the soft horizontals of cloud forms, largest at the top and diminishing in scale towards the horizon, contrast favorably with the angular silhouettes of the mountain range.

Notice that as the ground planes recede in depth their colors become grayer and less warm in tone.

Paper used was D'Arches, 300 pound weight, medium rough surface, 15 by 20 inches. For color, I used: Cobalt Blue, French Ultramarine Blue, Raw Sienna, Burnt Umber, Hooker's Green No. 2, Alizarin Crimson and Cadmium Orange. The sky was painted first on a dry surface with a series of direct, juicy washes, made up of a mixture of cobalt blue and a little burnt umber. Then the mountain silhouettes were brushed in, working from the highest (and lightest) peak first, graduating the value and color of the successive ranges. Now came the painting of the fields—again progressing from middle distance to foreground. At the last, the trees, fence posts and small details were indicated. Rooftops were left white until the end, when they were thinly colored.

THE OAKS

Among the several varieties of oak, the Northern Red Oak and the Southern Live Oak are particularly attractive to artists.

The Red Oak is a massive tree, sturdy and powerful in form. Its broad, symmetrical and spreading crown of dense dark foliage dominates the landscape wherever it is seen. When found in the open terrain, its trunk is usually short, dividing into several stout limbs from which its long branches twist and turn in angular movements.

In summer, the rich foliage provides generous shade from the sun, and in the fall when its leaves turn color, the deep reds and oranges delight the eye. Winter appearance is no less dramatic, for in this season the oak's beautiful structure is revealed in its noble proportions.

Turning to the South, we find the Live Oak which takes its name from the fact that it is green the year around. A short, heavy trunk divides into two or more spreading limbs, with an overall dimension of width at least twice its height. Spanish moss is often found clinging to its limbs and branches, providing an interesting pattern of verticals. Its warm gray color blends with the brownish-green limbs and branches as it sways gently to and fro in the slightest breeze. This hanging moss has been likened to old webs, giving the trees a rather sinister appearance, but creates at the same time a mellow note to the landscape.

On the following page I have painted two versions of the Red Oak—the first showing its full foliage, and the second, its skeleton form, barren of leaves.

In painting either of these states, the same procedure that I have described previously for painting trees is applicable here. However, there is one exception that should be called especially to the reader's attention. That is the "sky holes" between the large masses of foliage seen in illustration. These are larger in area than those seen in most of the previous trees, due to the fact that the heavy limbs grow farther apart and these support masses of dense foliage.

The large illustration of the Live Oak, at the bottom of the page following, is shown in its horizontally accented proportion, with streamers of Spanish moss hanging from its limbs and branches.

To paint such a tree, I use a square-end brush and begin the painting by producing the shadow areas of the foliage. This action does not go beyond the general shapes of these forms as they will be modeled more completely at a later stage.

Turning my attention to the main branches and limbs, I strike these in while the previous section is still damp —but as you can see, it was necessary to use a darker value to create these forms. Similarly, the trunk is painted, modeling its massive rounded shape with medium and dark values, leaving patches of white paper for the sunlit patterns. Note also, the indications of reflected light on the trunk and lower limbs.

The moss is modeled with dry-brush strokes in vertical sweeps. It can also be modeled by using the thumb to spread the pigment downward. Thought should be given to the placement of the moss, with special regard for its final effect.

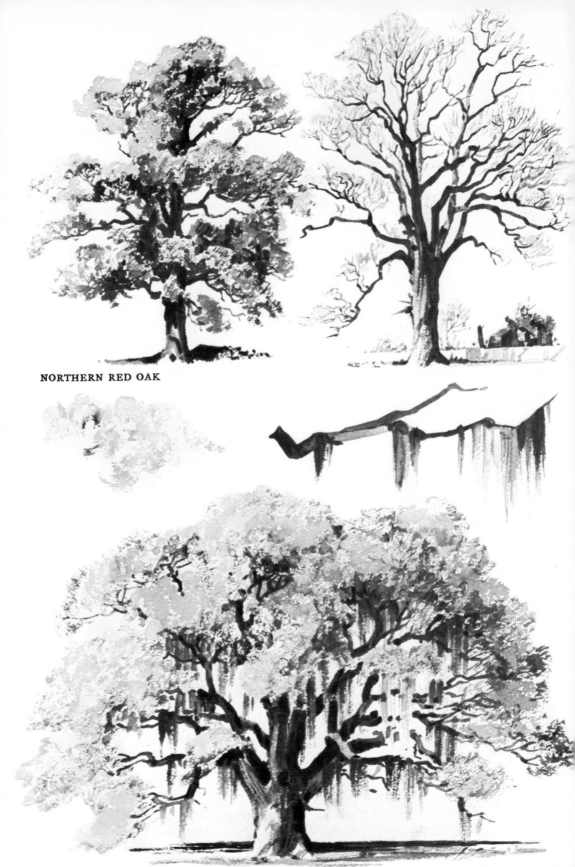

NORTHERN RED OAK

LIVE OAK

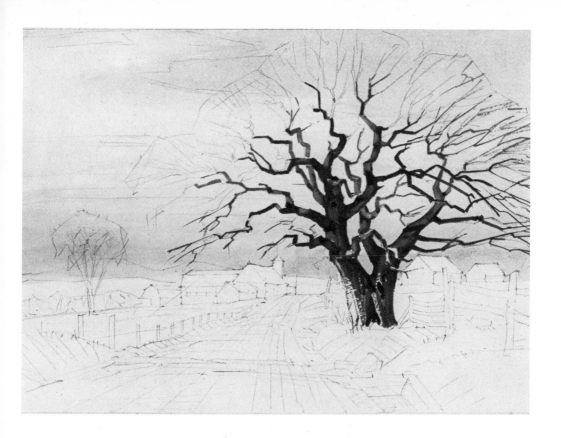

THE GNARLED OAK

The design of *The Gnarled Oak* (p. 44) began with the placement of a low horizon. This provided me with a sky area large enough to include almost the entire proportions of the large oak. The simple sky formed a quiet background for the active pattern of branches. A dark shadow cast horizontally across the road created a strong base and accented the sunlit area beyond it.

Perspective lines of road lead to the focal point of the group of buildings. Note how important the tree is in the left middle distance in balancing the large oak. The light reflections in the puddle in the left foreground and the white wall of the barn and white fence are calculated notes of value contrast.

A 300 pound D'Arches paper in the medium rough surface, and in size, 15 by 20 inches, was used. My palette contained Windsor Blue, French Ultramarine Blue, Cobalt Blue, Vermilion Red, Raw Sienna, Raw Umber, Aureolin Yellow, and Alizarin Crimson.

The sky pattern was painted first. The "settling" character of the darkest wash at the top added texture. The lower areas of sky were kept thin and pale to produce distance. The twisted and interlaced form of the oak was indicated by painting the dark shadow areas first, joining this with the warm-colored branches—finally producing the outermost twigs by dry-brush strokes in the manner previously described.

Background hills and farm buildings were dealt with next; to be followed in order by the dark foreground shadow, and then the middle-distant field.

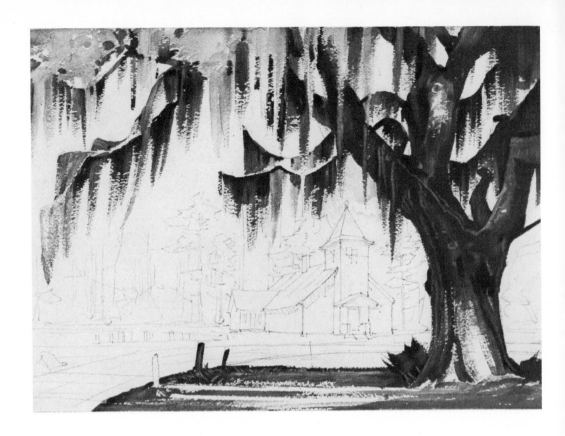

SPANISH MOSS

The framing structure of this design (p. 45) is clearly stated in the illustration above. Notice the pyramidal shape formed by the heavy branches made less obvious by the hanging moss.

My palette for this watercolor was composed of Cobalt Blue, French Ultramarine Blue, Raw Sienna, Burnt Umber, Alizarin Crimson, Davy's Gray and Hooker's Green No. 2. Paper used was D'Arches, 300 pound weight, medium rough surface, 15 by 20 inches.

The large oak in the right foreground was painted first, in the manner described on page 79. At the same time, the cast shadow over the foreground was brushed in, but terminated *temporarily* at the edge of the roadway. The background trees were blocked in around and back of the church. While practically silhouettes, these forms, varying in height and degrees of foliage, were planned carefully.

In painting the church next, you can easily see the advantage in the use of the square-end brush. This was especially helpful in modeling the clean-cut shadow areas. Roof and clapboard textures were varied to add interest; special attention was paid the warm and cool reflected lights. Middleground and roadway were indicated. Note that the strongest point of illumination is found at the curve of the road and the ground plane beyond it, to the left. Consistently, the left-hand vertical planes of the church were found receiving the strong sunlight—making it *artistically* obligatory to leave the white paper to form these patterns.

LOMBARDY POPLAR AND ASPEN

The Lombardy Poplar is a distinctive tree with its slender, erect posture. Frequently seen bordering roadways in long vistas, it is also found marking the boundaries of farmlands. Though its life span is short, it attains its full height in a relatively short period.

To the artist, this poplar has several interesting features. Its tall, slowly tapering cylindrical form is essentially decorative. The limbs and branches grow immediately upward in long sprouts from the sturdy trunk supporting masses of rich foliage. Often dead limbs may be seen (as in our illustration at the top, opposite) creating a contrasting pattern of silhouettes against the sky. Since the Lombardy Poplar is not a shade tree, its normal cast shadow is long and narrow.

Heart-shaped leaves grow on long stems which allow free movement, causing them to rustle in the slightest breeze — and producing a sound not unlike the murmur of a rushing brook.

While I have chosen to paint the watercolor picture on page 47 in the daylight, the same motif would be equally worthwhile in twilight, when these trees in silhouette would create an arresting atmosphere.

The painting of the poplar is similar to that of other trees previously illustrated. Start with the dark pattern of the foliage and then paint the trunk and branches — coming to the sunlit areas of the leaves at the last. By working in this order, you will be able to control the values.

In the illustrations of poplars following, take notice of the textures. These were produced by the "lifting" of the dry-brush strokes over the rough surface of the paper.

The Aspen tree, illustrated in the lower half of the page following, is a variety of the poplar but to the average eye it resembles the general character of the birch tree. This is true especially in its light-colored bark with its dark markings. Its main difference, however, lies in the leaf construction, which like the Lombardy Poplar, is suspended on a long, ribbon-like stem and consequently trembles in the breeze — hence its popular title: the quaking aspen.

This tree grows from sea level to mountain heights. It thrives on moist, sandy soils and rocky hillsides. The aspen is found in the Northeastern States and in the Far West. Often it grows on clearings which have been burned over.

In the autumn, its leaves turn from dark green to a golden yellow before dropping. When grown in the open (as pictured in our illustration following) the trunk is straight and its overall form quite symmetrical.

To paint the quaking aspen, begin with dry-brush strokes and model the general masses of light-colored foliage, leaving the trunks and main branches white paper, wherever practicable. Branches in shadow, and those on the far side of the tree, will require an accenting value. In composing a group of aspens in a particular watercolor, I suggest finding a good natural excuse to foil them against a dark background — a group of evergreens or mountain form — so that the light trunks can be exploited.

Without foliage, the aspen is a slender form with thin branches and twigs of a reddish color.

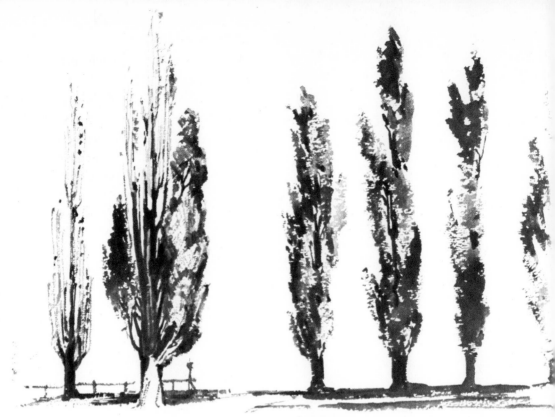

LOMBARDY POPLAR

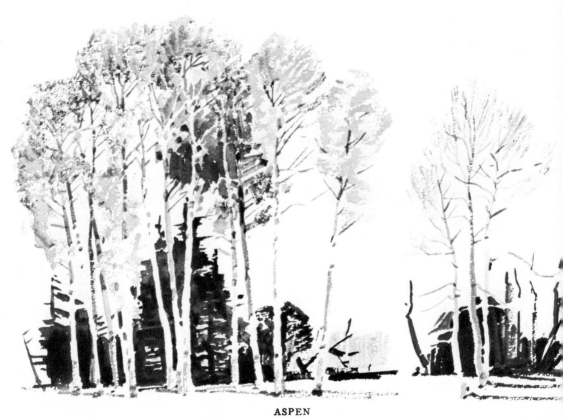

ASPEN

84

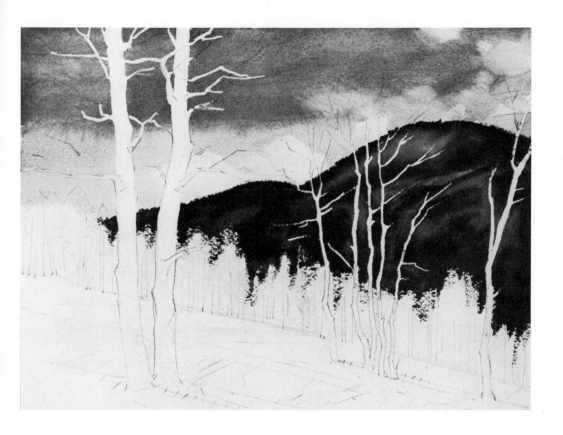

ASPEN GROVE, COLORADO

My design for this picture (p 46), shown above, combines strong verticals (found in left foreground, and middleground), and a top horizontal line of the cloud in the sky and balancing obliques. Almost needless to say, the placement of these vertical tree forms in the foreground and middleground was very important. When the drawing of these trees was completed, I blocked out their forms with latex, in order to paint a continuous background of cloud and mountain *over* them. When these washes of sky (first) and mountain (second) were dry, I rubbed off the liquid rubber, leaving white silhouettes, to be modeled in "the round" as a final step.

The grove of aspens in the middle distance was brushed in, taking care not to disturb the lacy edges at the top of the silhouette. This character, seen in the illustration above, was produced at the time of painting the mountain passage.

Foreground plane was painted with a rich, warm local color predominating in the nearest central area—to the right of the two largest aspens.

The foreground trees were modeled next with special emphasis placed on the shadows and reflected lights, leaving the high-lighted sections patterns of white paper.

Paper used was D'Arches, 300 pound stock, medium rough, measuring 15 by 20 inches. Palette—Aureolin Yellow, Raw Sienna, Burnt Umber, Alizarin Crimson, Hooker's Green No. 2, Cobalt Blue, Cerulean Blue and French Ultramarine Blue.

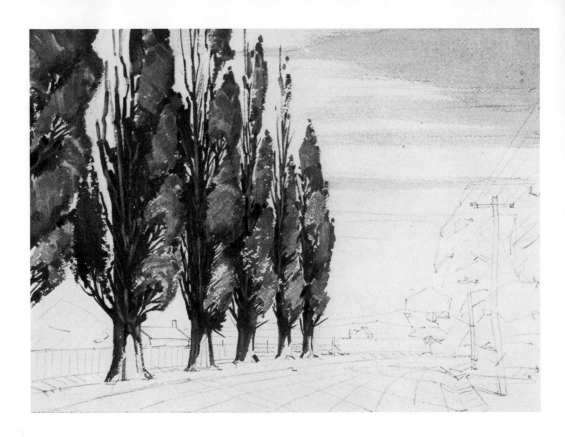

POPLARS

The row of poplars (p. 47) that ends to the right of the middle axis, was balanced with a small mass of other trees at the extreme right. This combination was foiled against a simple sky made up of graduated horizontal cloud forms. A low eye level helped to place the perspective accent on the form and scale of my foreground, leaving the far stretch of the background a pattern of simple silhouettes. Cast shadows from other poplars outside the picture plane, cross the roadway from right to left at an angle, pointing to the motif.

I used my favorite D'Arches again in the same surface, weight, and size as in the previous picture. For color, I selected two blues—Cobalt and French Ultramarine; two earth colors—Raw Sienna and Burnt Umber; Cadmium Orange and Aureolin Yellow; Alizarin Crimson and Vermilion Red.

The order of painting was begun with cobalt blue wash strokes for the sky, indicating horizontal clouds. Then followed the dark pattern of the poplar trunks and branches. When this part was dry the foliage masses were added —modeling these in light and shade and varying the color from warm green in the largest tree on the left, to the cool green on the farthest one to the right. Then the background immediately behind the poplars' trunks, the distant background, and the trees to the right, in that order. Finally, the roadway was indicated—largely made up of transparent cast shadow patterns in which the nearest ones show the warm local color, with cool color at the edges.

MONTEREY CYPRESS

The Monterey Cypress, as its name implies, grows in its natural habitat in a concentrated area around Monterey in California along the Pacific Coast, from Cypress Point to Point Lobos. Here on the rocky cliffs exposed to the strong sea winds, these cypress trees exhibit the twisted and grotesque forms that make them such fascinating motifs for the artist.

As young trees, they have conical forms with comparatively straight though heavy trunks, and branches which grow upward forming a pyramidal crown. However, from a picturesque standpoint, we are mainly concerned with its weather-beaten old age. In this condition, its strong limbs as long massive arms, reach out and up, supporting the dense flat-topped foliage. The pyramidal crown of its youth has given way to a flat-topped crown, like the one I have illustrated at the top, following. The color of the foliage is a rich dark green, with a trunk which is a brownish gray and silvery gray, when dead.

Often the trunks and heavy limbs sprawl on the ground, where, exposed to the elements, they twist and gnarl in a writhing fashion. The sharp bends take on a form not unlike that of the human elbow, widest at the angular turn. The fine texture of the bark follows the movement of these twists and may be seen to an advantage in my illustration, at the bottom of the page opposite.

Lest my readers identify this Monterey Cypress in localities other than in California, it should be readily stated that this tree has been planted in other places, where, under favorable conditions, its cultivation produces a graceful, symmetrical tree. It is used frequently in California for windbreaks, as its rather rapid growth when young makes it useful for this, and also, for ornamental purposes.

To paint the cypress represented in the top illustration following, I recommend beginning with the dark mass of foliage, working around the bare whitened limbs. Next, model the shadow areas of the trunk, limbs and branches—producing the textured character with dry-brush strokes. Typical strokes for this technique are illustrated at the right.

The illustration below pictures a dead and weather-beaten cypress in a close-up. In this, and in all other trees for that matter, the initial drawing should not be slighted. By this I do not mean a highly detailed drawing, but rather, a pencil draft that concerns itself with major proportions and special emphasizing of individual characteristics. The latter is exemplified in this dead cypress. Without a well-planned drawing it would have been difficult to create the picturesque irregularities and the flowing rhythm of these textures. With such a pencil foundation, the actual painting was sheer pleasure.

I began the painting with a dark wash, blocking in the shadow areas, then moved on to the middle values, keeping the wash thin enough to reveal its transparency. At this stage, a large part of the main forms were areas of white paper. By using the square-end brush, separated in the fashion described in detail on page 21, I began modeling these high-lighted forms with light strokes, following the rhythmical pattern of the surface textures.

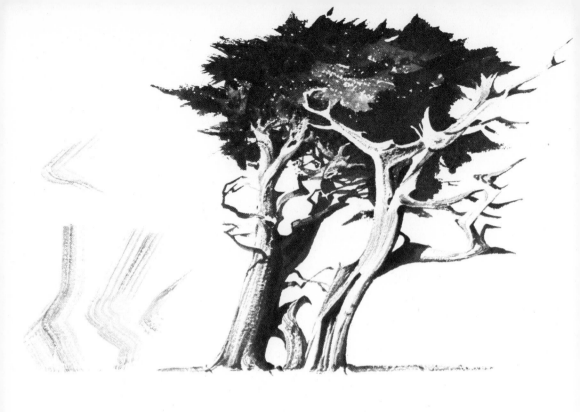

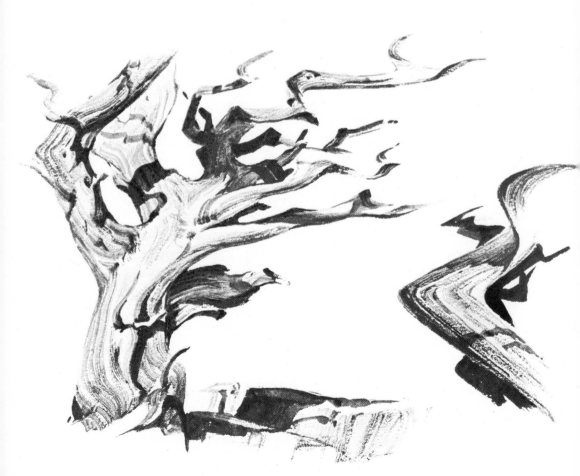

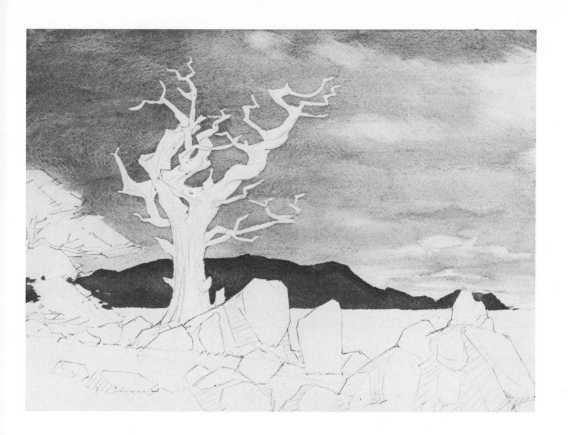

AT CARMEL BAY, CALIFORNIA

In the plan of my composition (p. 48), notice that the low horizon and shallow foreground placed special emphasis on the dead cypress. Balancing its dramatic silhouette with the mass of rocks, I foiled the agitated movement of the old tree against the quiet forms of a calm water plane, mountain, and horizontally accented sky.

The sunlight flooding in from the right, struck the sides of rocks producing strong value contrasts. Rich warm local color in the foreground with the silvery skeleton of the cypress made the middle and far distance recede in space.

For this picture, I selected a full sheet of rough Whatman paper, 22 by 30 inches, in the 300 pound weight. The colors used were: Cobalt Blue, French Ultramarine Blue, Raw Sienna, Burnt Umber, Alizarin Crimson, Aureolin Yellow, Vermilion Red, and Hooker's Green No. 2.

After I had made a careful pencil sketch with special attention to the forms of the cypress, I brushed in the tree with latex. Over this I painted the sky, with a warm wash at the top and a cooler and lighter tone at the horizon. Then the mountain silhouette was indicated and the latex removed.

And now in order: the water plane; the live cypress on the extreme left; the rocks, working from the far right to the left and including the foreground; and finally, the dead cypress—brushing in the darks first, and finishing with the middle values in dry-brush strokes, leaving passages of white paper to create its silvery, high-lighted surfaces.

PRACTICE SUBJECTS

In this last section of my book (pages 90–96) I have prepared ten compositions in pencil outline for the benefit of my readers. It is my suggestion these be used as practice subjects in the following ways.

As each of these is a variant of one of the finished pictures reproduced in color and the reader has been carried through the various steps of technique, he can use these layouts as a kind of springboard for his own imagination. By enlarging these drawings to 15 by 20 inches on a good sheet of medium rough watercolor paper, the reader is absolved of the problem of design—he must begin to practice the knowledge gained from the foregoing chapters.

He must decide on the kind of day and season; the direction and quality of the light; a color scheme; and a good dark and light pattern. A good intermediate step to painting in color would be to make a smaller study in monochrome, similar to my sepia paintings on page 14. This would not only provide excellent practice for brush strokes but would settle the value problem as well. Consider the composition of old willows above. I suggest that the student paint this one in a foggy atmosphere like the picture reproduced on page 33. By using the same palette and following the painting order I have described, the student will see for himself the practical reasons for my procedure.

The composition on page 91 has been laid out to provide a lesson in painting a grove of birch trees. The reader will remember from our chapter on this

tree, that to get the most out of this subject, the artist needs to foil the light-colored birches against a dark background. Notice that I have prepared this opportunity, by arranging the trees in foreground and middle-ground on a sloping plane—so that a large proportion of their trunks may be accented by a dark background of hill and trees.

The Sierra Juniper on the next page at the top, dominates this composition. Try using the same color scheme for this one as in the picture on page 89. The sunlight, striking the foreground from the right side, will give you an opportunity to use warm local color— with a dark gray blue mountain form in the background, contrasted with the high-lighted silvery trunk of the juniper.

Try using dry-brush strokes to model the foliage and weather-beaten textures of the trunk and limbs.

For the picture of maples, I suggest using a limited palette composed of Windsor Blue, Cobalt Blue, Raw Sienna, Vermilion Red and Hooker's Green No. 2. The pattern of foliage on the foreground and middle distant maples has been clearly outlined, indicating a late fall scene. Here is your chance to paint a colorful picture with the same strong value contrasts as those found in the watercolor, reproduced on page 42. The village street scenes on page 93 may be painted with a limited palette of Burnt Umber, French Ultramarine Blue and Hooker's Green No. 2. With these three colors and a little imagination, you can try a rainy day atmosphere

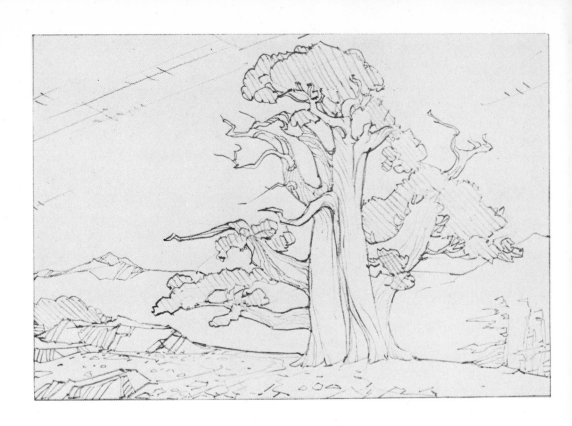

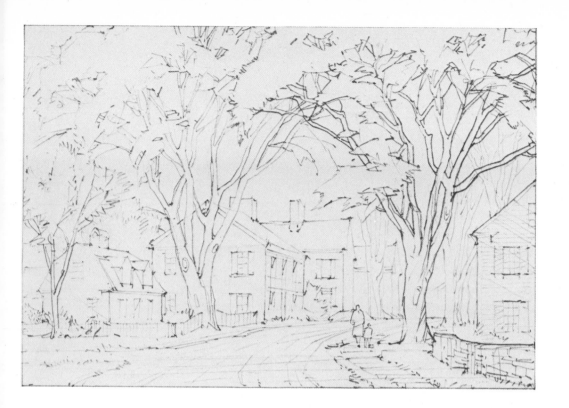

following the suggestions indicated in the sepia illustrations on page 14. Do another with a pattern of flickering sunlight by enlarging the palette above, to include **Vermilion Red, Raw Sienna and Cobalt Blue.** Keep the left side of the road lightest, as the illumination is indicated in the drawing to be coming in from this direction.

The sycamore tree following has been brought into the foreground to give my readers a chance to paint its striking form in large proportions. Study the watercolor on page 63 and follow the same general atmosphere and color scheme. Vary the tonal arrangement so that the tree will appear light against a dark background. Here, I would suggest using the latex on the trunk and limbs of the tree because this will great-

ly facilitate the painting of the sky. For the palm picture, you may paint a tropical mood with a light atmospheric sky, with a dark value for the water plane. The foreground tree trunks can be in shade with accentuated reflected light from the warm sandy beach. Again, the pencil drawing suggests that the illumination is coming in from the right, which should be indicated by a graduated value scale—lightest at the right side.

In painting a watercolor from the pencil drawing on page 95, study the picture of the live oak on page 45. Similarly, I suggest keeping your foreground darkest, with the tree form largely in shadow, except for a spot of sunlight hitting the base of the trunk. Model the hanging moss as described on page 82,

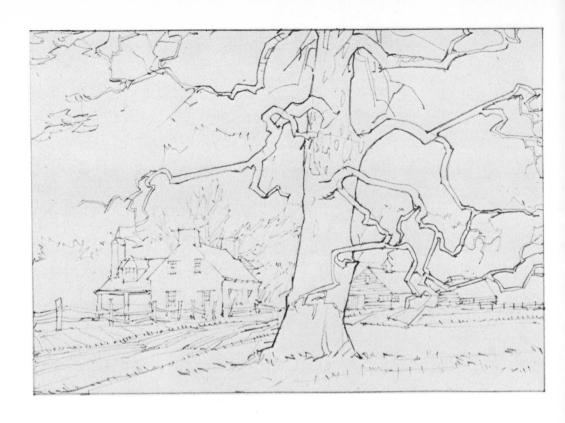

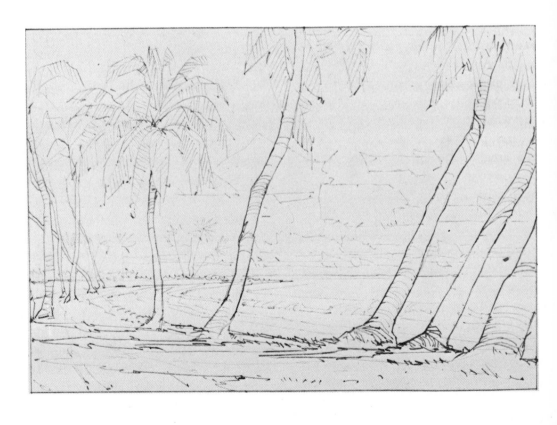

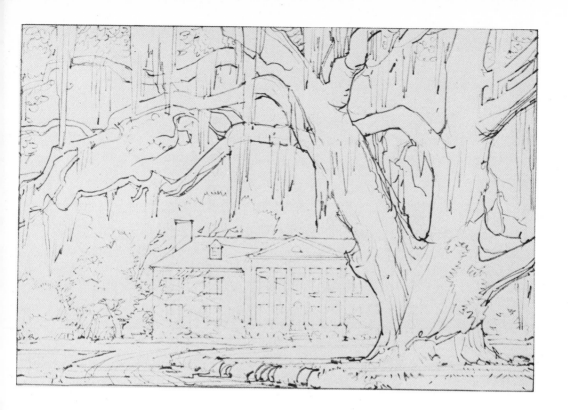

leaving the sky area entirely white paper to the very end. Reflected lights on the trunk and limbs can be effectively produced by knife strokes.

Since poplars are particularly interesting when seen against a light background, paint the sky accordingly. Wet this area with water and float in the desired color, graduating the tone from darkest at the top to the lightest value at the horizon. Give a middle value to the distant mountains, a darker value to the middleground, with the foreground lightest. Reserve the ranchhouse for an accent of light color against its dark background of tree foliage.

The student will find a helpful scheme for painting this variant of the Monterey Cypress by studying the color plate on page 48. This being a live tree, its foliage should be a rich dark green which can be painted with Hooker's Green No. 2 and a touch of Burnt Umber.

In addition to the definite suggestions which I have made concerning each of these ten subjects, the student will find it valuable practice to make other studies with: (1) various color schemes; (2) changes of light direction; (3) varying of atmospheric effects (rain, fog); and (4) changes of season. Finally, try to enlarge your half-sheet scale to full size (22 by 30 inches).

In conclusion, I suggest that my readers make numerous outdoor watercolors, applying the instruction they have gained from studying my book. Painting nature with knowledge is not the act of copying, but rather a basis for the artist's personal interpretation.

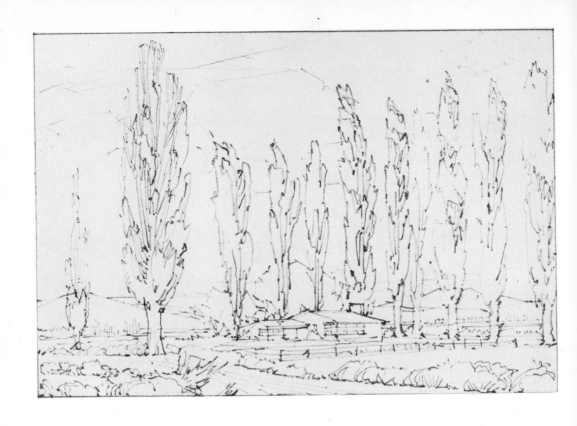

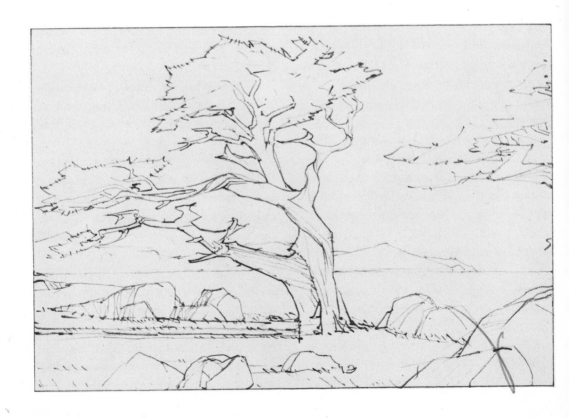

DATE DUE

PRINTED IN U.S.A.